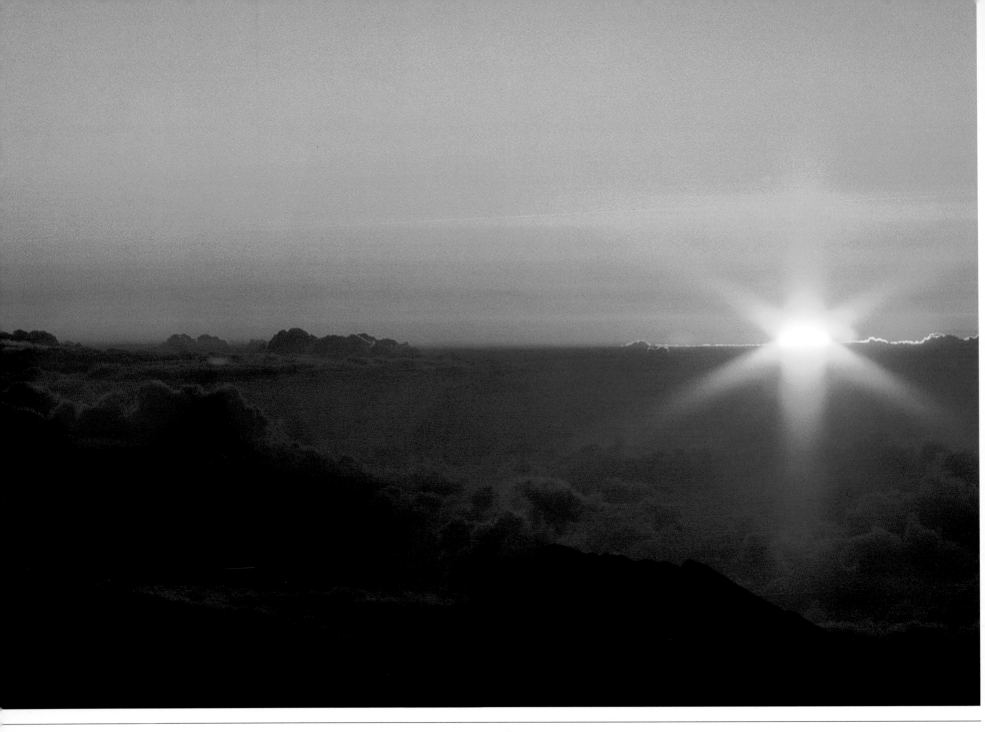

First Light

Nature's Palette

Art Through a Photographer's Eyes

Michael T. Ingalls

Nature's Palette

Art Through a Photographer's Eyes

Michael Thomas Impellizzeri

 Publishing

Book design and production: Tabby House
Cover design: OspreyDesign
Manufactured in China

Acknowledgments

*Nature is painting for us, day after day,
pictures of infinite beauty, of only we have the eyes to see them.*
John Ruskin

I wish to acknowledge the many people who have shared with me their insights, experience, encouragement and enthusiasm in the development and production of *Nature's Palette: Art Through a Photographer's Eyes*. I would like to thank my working colleagues and friends at Yellowstone and Grand Teton National Parks, where I spend my summers. I would like to recognize and thank Jane Andrews and Sharon Hodges for their candid feedback and editorial support on several draft copies. Chuck Venturi was instrumental in providing natural history guidance. Nature is the common denominator for this project. The unique interpretations of what we all see and the way one responds to the marvels of nature is a lesson in itself.

 Publishing

3855 Cape Cole Boulevard
Punta Gorda, FL 33955

To Amy, Jason and David

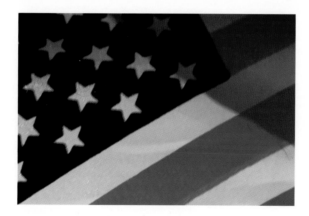

A thoughtful mind, when it sees a nation's flag,
sees not the flag only, but the nation itself; and
whatever may be its symbols, its insignia, he
reads chiefly in the flag the government, the
principles, the truths, the history which belong
to the nation that sets it forth.
Henry W. Beecher

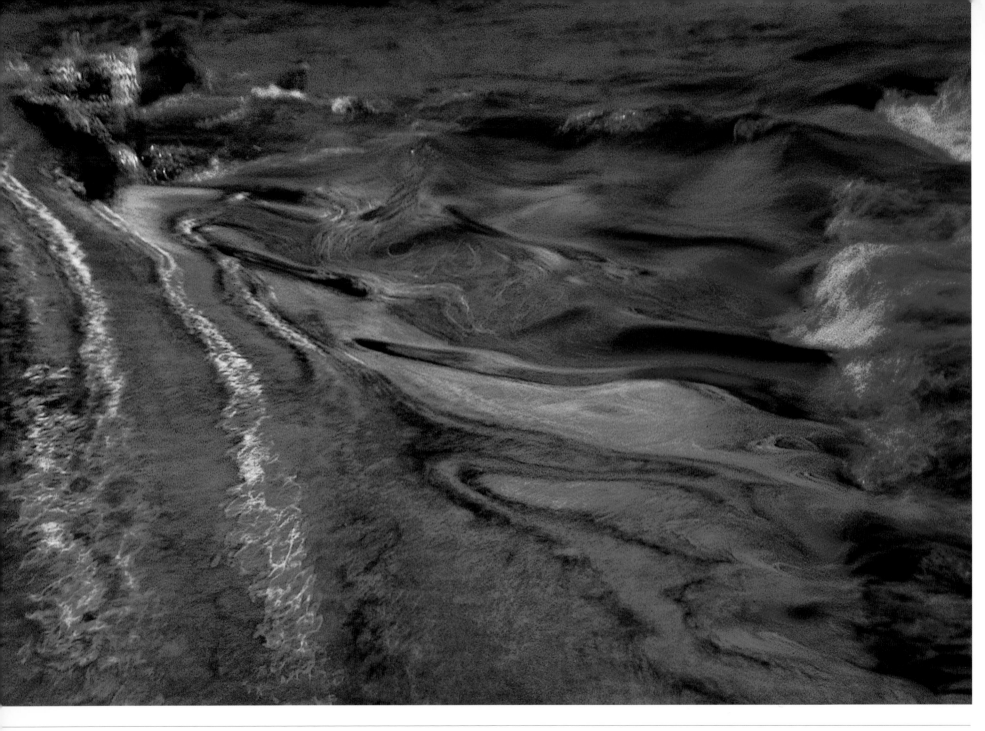

Autumn Magic

Contents

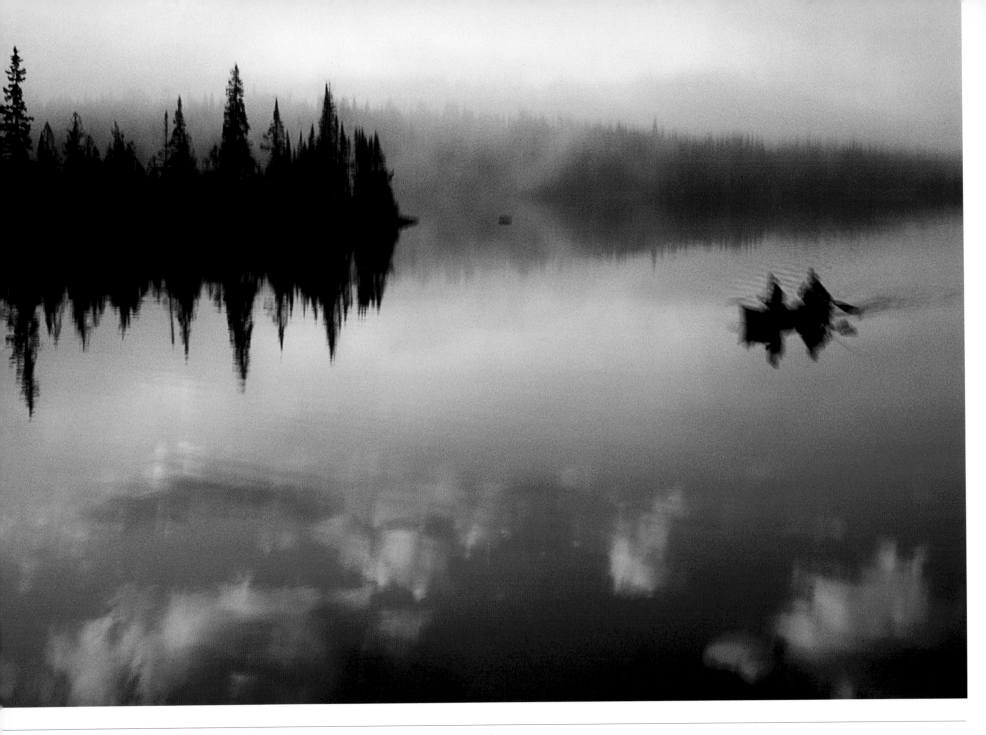

Summer Blues

Introduction

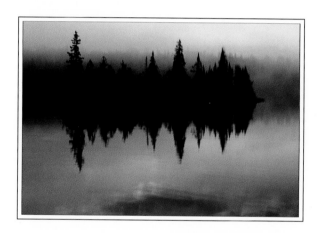

In every walk with nature, one
receives far more that he seeks.
Anonymous

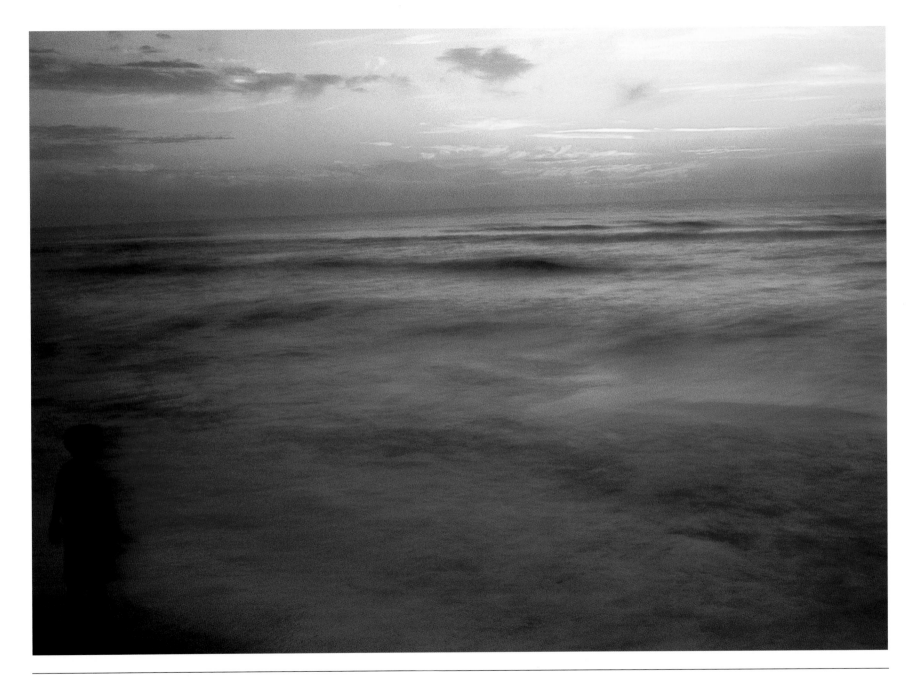

The Lure of Nature

The Lure of Nature

Stop for a moment and visualize the following: rest stops, navigators, lumberjacks, anglers, architects, sentries, flight patterns, cloverleafs, music, camouflage, competition, skyscrapers, hunters and thieves. They remind me of the annual migration of birds and whales, the music of a gentle stream, the colors of birds, animals whose dress blends with their surroundings, and nature's first lumberjack, the beaver. The words remind me of a fox who steals food and cameras from backpackers, trees that reach to the sky, a soaring eagle fishing for the catch of the day, the spider as a web designer, and birds who build a nest from nature's discards. Did any of the words remind you of the urban world . . . the natural world?

The attractions in the natural world and the names we associate with them have found their way into the metaphors of urban life. I have spent quality time in the great outdoors close to home and on adventures across our diverse landscape, enabling me to appreciate their original meaning. Nature has many personalities and moods created by the weather, a place of constantly changing drama. The setting sun paints the sky, a blazing sunrise welcomes a new day and multicolored leaves signal the end of one season and the beginning of a new one. The rhythms of nature create a new palette, paint a diverse tapestry and provide a mosaic pageant daily—a slide show changing from one moment to the next. Mother Nature's stage becomes an always varying spectacle. It produces an encore performance daily.

I see nature as a classroom to the world that nurtures one to see, feel, experience and explore. I see the road to riches as a footpath in the woods or a trail on a mountainside. Nature is a life raft of relaxation and a sanctuary of surprise, discovery and recovery. Nature is a pharmacy—medicine for the soul. It is a supermarket where one chooses from among its many offerings. Nature's language is beauty that has intrinsic value. What first appears, as chaos is actually an orderly ever-changing stage throughout the year. Moreover, nature is a teacher of wisdom. It beams lessons to us.

Let nature be your teacher.
William Wordsworth

I see nature as a classroom to the world.

Nature's Wisdom

Several years ago I read an article titled "Lessons we can learn from geese." The original source is attributed to Milton Olson and I know these are lessons worth sharing.

Fact No. 1. As each bird flaps its wings, it creates uplift for the bird following. By flying in a V formation, the whole flock adds 71 percent greater flying range than if one bird flew alone.

Lesson No. 1. People who share a common direction and sense of community can get where they're going more quickly and easily because they're traveling on the strength of one another.

Fact No. 2. Whenever a goose falls out of formation, it suddenly feels the drag and resistance of trying to fly alone and quickly gets back into formation to take advantage of the lifting power of the bird immediately in front.

Lesson No. 2. If we have as much sense as geese, we will stay in formation with those who are ahead of where we want to go and be willing to accept their help as well as give ours to others.

Fact No. 3. When the lead goose gets tired, it rotates back into the formation and another goose flies at the point position.

Lesson No. 3. It pays to take turns doing the hard tasks and sharing leadership.

Fact No. 4. The geese in formation honk from behind to encourage those up front to keep up their speed.

Lesson No. 4. We need to make sure our honking from behind is encouraging, and not something else.

Fact No. 5. When a goose gets sick or wounded, two geese drop out of formation and follow it down to help and protect it. They stay with it until it is able to fly again—or dies. Then they launch out on their own, with another formation, or they catch up with their flock.

Harvest Moon

Lesson No. 5. If we have as much sense as geese, we, too, will stand by each other in difficult times as well as when we are strong.

I enjoy being on the eastern shore of Maryland and Delaware in late autumn before sunrise to see Canada geese launch themselves as the sun rises above the horizon. Their raucous chorus of honking music is only slightly muted by the sound of their flapping wings while taking flight. The wisdom of nature, coupled with the knowledge that one learns from personal experiences, is like a schoolhouse full of lesson plans. This sense of discovery has inspired me to paint the essence of the natural world with a camera.

Art and Photography

Nature has taken me by the hand and by the heart and has influenced the canvas of my life and my approach to photographing the natural world. Being inspired by special places and magical moments has been instrumental in influencing me to pursue photography as an art form. Film is simply a canvas on which I paint images with light. My camera and techniques are to a photograph what a car is to a trip; they get me there but are not the reason for my journey. My journey is one of discovery. I see my camera not as a tool to be mastered but as a window to see things differently. Hunting with my camera allows me to make an image that asks a question rather than answering one. My goal is to arouse the curiosity of the viewer, tease the mind and provoke the senses in the images I create.

Every artist dips his own brush in his own soul,
and paints his own nature into his pictures.
Henry Ward Beecher

My approach to nature photography has gradually changed from the representational or documentary sharp image to one that reflects the soul of the experience. Nature photography is my vehicle for creative artistic expression. Rather than describing the subject, I strive to communicate the feelings the subject radiates. Through trial and error I have learned to use the shutter as a paintbrush. The simple act of pushing a shutter can be elevated to an art. The resulting visual poetry is testimony to the aura of beauty.

Pictures talk with emotions.

In recording nature with my camera, I view painterly photography with a new mental focus; the sun is the light, nature is the palette, the camera is my brush, the lens is the paint, and the film is the canvas. Photographic techniques are my brush strokes. Through soft focus, double and multiple exposures, creative zoom, time lapse, slow shutter speeds, montage and camera shake, I have been able to capture images that reflect artistic expression, which comes from within. I have learned that the mind talks in words and pictures talk with emotions. Therefore, my images deal more with impressions, not facts, with feelings, not observations. Artistic interpretation of the natural world stirs my emotions, awakens my curiosity and stimulates my senses.

Why Nature Photography?

Nature photography has taught me to measure a day by heartbeats instead of a clock. No second hand will tell me when and what I have seen. I can glance at water rushing down a stream, feel the wind rustling through trees, hear the roaring of thousands of honking geese flying overhead, or watch the splashing waves on a sandy shore—not realizing time is passing by. Nature is a place to wonder and wander. It is a place in which to get lost, as well as to find oneself. The essence of the moment is timeless in a never-ending theater. Pure joy is to catch nature as it happens. A journey is to capture the experience that cannot be repeated, but can be shared.

> *Much is published, but little is printed.*
> *The rays, which stream through the*
> *shutter, will be no longer remembered*
> *when the shutter is wholly removed.*
> Henry David Thoreau

A good visual image must grab me. It may be instant, totally unexpected or I may have to wait for a million heartbeats until I see and feel what nature has in store for me on any day. Nature photography is a form of meditation; it is reacting to what is before my eyes. Most of the time I cannot touch the wildlife; a roseate spoonbill flying into camera view, a black bear playing with her cubs on a carpet of flowers, a herd of bison storming out of the woods to escape the charge of a grizzly bear, or two whales breaching just twenty-five yards in front of me. Although I cannot touch these creatures with

Measure a day by heartbeats instead of a clock.

my hands, they touch me. Nature photography taught me to see with my eyes and feel with my heart. When I see it and feel it, then, and only then, can I capture the essence of the moment.

I arrived at this nature photographic interpretation over time. Like so many, I enjoy being outdoors. I enjoy the pleasure of natural places, forests and mountains, the sound of birds, the joy of a walk along the beach or a trail through the woods. Enjoying nature was not enough—I wanted more. I learned not only to see it but also experience the natural world with all my senses.

I began to paint my sensory experiences on film, transferring the engraving on my mind to the emulsion of photographic film. It became a challenge to capture "the seeing and the feeling" of a moment in time. I enjoy capturing nature's banquet on film and I want to share my experiences with others—many who have not or cannot roam the great outdoors. I want my images to evoke a mood, create a smile, convey a feeling or stir one to reflect. My challenge is to communicate the essence and emotions of nature. I want my heartbeats to be felt and enjoyed by others.

Opportunities Presented, Photo Opportunities Missed

Did you get it? Did you see that double rainbow? Did you get that great shot? How many shots of the grizzly bear did you get? Can we leave now? No. No. No. No. No. I haven't gotten every shot I wanted or clicked the shutter on what others were seeing. Nature is a great teacher and I am its student. There are many lessons to learn from successes as well as failures.

Images not captured on film are disappointing but also have been my greatest teacher; I have run out of film during a breathtaking experience; I have had a dead battery at the wrong time; I have failed to reload film fast enough; and I have not always been ready or perceptive. There have been times when I simply did not have a camera with me when I should have.

For example, I have had two great opportunities to photograph whales and missed both times. The first time I was in a catamaran on the Atlantic Ocean twenty-five miles from

> *Capture the essence of the moment.*

Bar Harbor, Maine, on a whale-watching trip. My first experience let alone the first time to ever see whales other than in a picture or movie. I can still see the image—a full-framed, sun backlit, whale tail waving at me as I saw it through my lens. I pressed the shutter, but the shutter did not, and would not click. A flashing battery warning appeared on my control panel. My camera battery was dead! As I hurried to replace the battery three dolphins jumped over the front hull of the catamaran. This was a double-miss, one being the vivid tail before my camera's eyes and the other being the airborne dolphins fewer than fifteen feet away in a full, unobstructed view.

The other time I "missed" a whale photo opportunity, I was sitting on a picnic table on a beach after returning from a whale-watching trip off the coast of Maui. This was a case of not expecting the unexpected. After all, I had paid to see whales earlier that same day, and yet, right there in front of me fewer than thirty yards from the shoreline, two whales breached in front of me, again, then again, five times in total. I ran to my car to grab my camera. The whales did a complete flip for me—as if to say good-bye, as I was running back to the beach to capture the moment, which I missed altogether.

I have experienced nature with a mix of excitement, exploration, discovery and challenge. The natural world is full of marvel and surprise that maybe revealed to the patient observer. I have been a patient observer. I have also been a distracted observer. On one occasion I waited for over three hours to see an eagle take flight. Someone came by and asked me what kind of camera I had—at the same time the eagle took flight in my direction not more than twenty-five feet over my head. While responding to his question, I "missed" the shot. Another lesson learned! Nature is always renewing itself. I have learned there will be many more gifts presented for me to capture on film. Memories of missed opportunities have been a valuable lesson for me to broaden my vision of nature photography. There is no one best shot. Missed pictures have been like a shot in the arm, learning from lessons from the past and exposing me to opportunities that wait in the future. I don't want my images to be a mere copy of nature, but a unique and distinctive brush stroke of my experience.

> *Missed opportunities have been a valuable lesson.*

Questions Pondered, Situations Observed

During my quest to capture beautiful images, I have talked with many people. I have shared stories and tales with others who would listen. My overall impression is that many individuals have seen natural wonders: however, they have not "experienced" all that the natural world has to offer.

One summer in Yellowstone National Park I was asked, "Where are the bear rides?" "What," I asked! The first thought that came to mind is the motto inscribed on the Roosevelt Arch at the northwest entrance: "For the benefit and enjoyment of the people." There is a major difference between a "national park" and an "amusement park." Numerous signs say: BISON ARE WILD—DO NOT APPROACH. While in the field photographing, I would occasionally see individuals get too close to the wildlife, either from the excitement of the moment or a temporary loss of common sense. When warned, the response sometimes would be, "If these animals were wild, the government would not let them run loose."

I have observed some dangerous situations while enjoying the natural world. One morning I was out in the field photographing Rosie, an infamous black bear, and her two cubs. A bear sighting always draw an instant and large gathering. Two young girls came flying by me on their way to pet the cubs that were feeding on a patch of wildflowers. I yelled at them to stop and walk back. Their father told me to mind my own business. I responded that they were in danger, being between the sow and her cubs. The excited girls did hear me, to my delight, and slowly walked back. Later, the father came up to me and apologized for his behavior.

I ponder and wonder when asked: "Do they turn off Old Faithful at midnight?" "What zoo does Yellowstone National Park get its animals from?" How long will the waterfalls be on?" "When are they going to pave the hiking trails?" "Where are Wal-Mart and MacDonald's?" These questions and observations are not what one should take away from their experience in the natural world.

MICHAEL THOMAS IMPELLIZZERI

What zoo does Yellowstone National Park get its animals from?

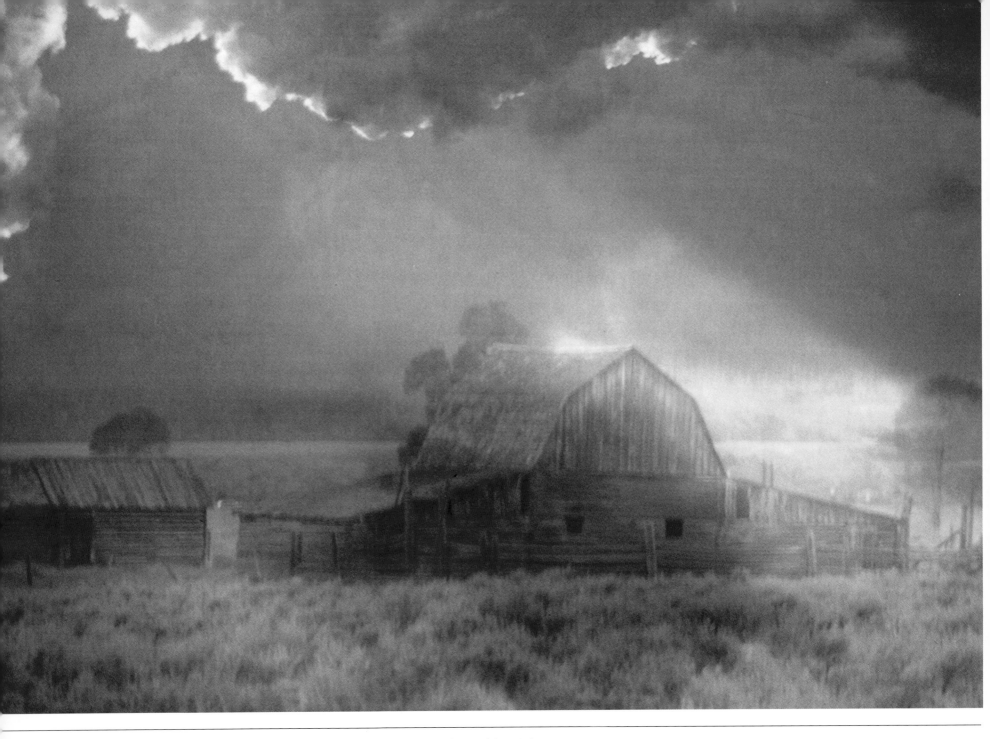

Embraced by Light

The Tapestry of 'Scapes

Beauty is no quality in things themselves: it exists merely in the mind which contemplates them.
David Hume

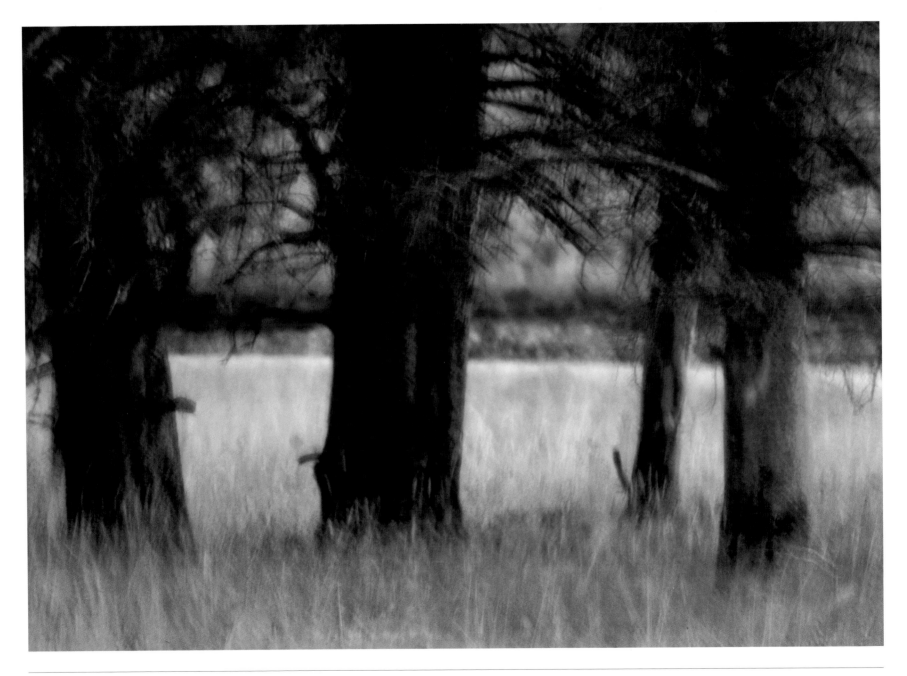

Autumn Magic

Light is a paintbrush creating a picture with one broad stroke. Falling light on the interplay between land and sea changes a scene with every blink of the eye. Looking 360 degrees from Mt. Whitney's 14,495-foot peak or across the gently lapping waves to the slowly sinking horizon into the vast sea, strolling through the lodgepole pine forest scented by an early morning spring shower—all these firsthand experiences have put me in touch with nature. Nature is full of surprises, wonder and grandeur. The rich, varied kaleidoscope presented from awesome redwood forests to a parade of ants hauling food to their underground estates, piques my curiosity and offers unique opportunity for exploration with my lens.

There is a pleasure in the pathless woods, there is a rapture on the lonely shore, there is society, where none intrudes, by the deep Sea, and music in its roar; I love not Man the less, but Nature more.
Lord Bryon

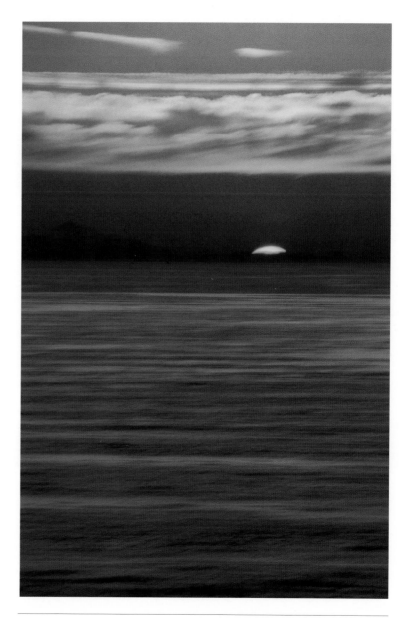

Evening Vespers

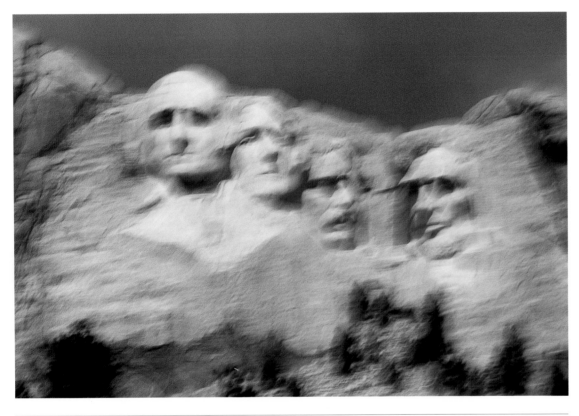

Time Passes By

The beauty and variety of landscapes, seascapes and skyscapes are endless. They are the foundations of the essence of place and where weather determines its moods and gives life to the land. We see the beauty, and then we feel it. From sea to shining sea—the coastlines of the Atlantic Ocean, the mountains and valleys of Appalachia, the Great Lakes, the mighty flow of the Mississippi River, the Great Plains or barren southwest deserts, the Rocky or Sierra Mountains to the shores of the Pacific Ocean—the mosaics of the land and seas are canopied by the clouds and skies.

The pageantry of the landscape is constantly changing by the second, hour, day and season. In one day I experienced the diversity of the landscape. I awakened up on a cool and dry morning at 12,500 feet, trekked to the top of oxygen-depleted Mt. Whitney, returned to pick up my camping gear and walked down the barren granite trails toward the upper tree line of the scented forest. While hiking in and out of the lush green and then barren trees, I marveled at the sights and sounds of this outdoor cinema. On the valley floor carpeted with seasonal cycle of wildflowers amidst the slow-moving streams, butterflies and bees were going about their daily business. I then drove from the highest elevation in the same county and same state to the lowest point in the continental United States.

The landscapes were like a violin bow
that played upon my soul.
Stendahl

Morning Glory

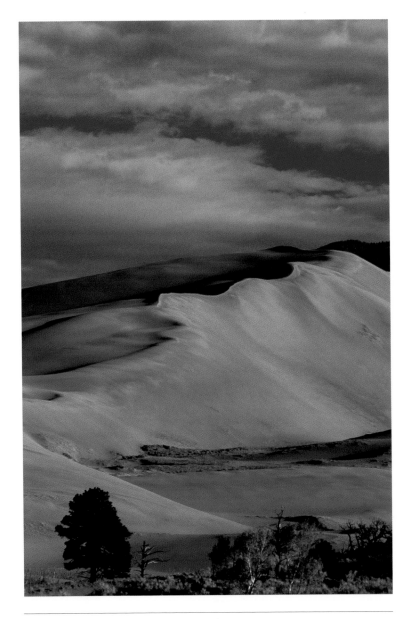

Whispering Sand

As I arrived in California's Death Valley with the air conditioning on, the view was like looking through a window onto a land far removed in time and distance from where I started the day's journey. The mosaic-like expanse of the desert pavement of sand and packed rock was formed by wind and water. At twenty-two feet below sea level I walked to a pool of water in the distance, I didn't need to go far before realizing just how hot a temperature hovering at 126 degrees was. It wasn't until I arrived home that I fully appreciated what I had witnessed on that adventurous day. The magical landscapes, full of spectacular and natural wonders, were a kaleidoscope for the eye to see and the heart to feel.

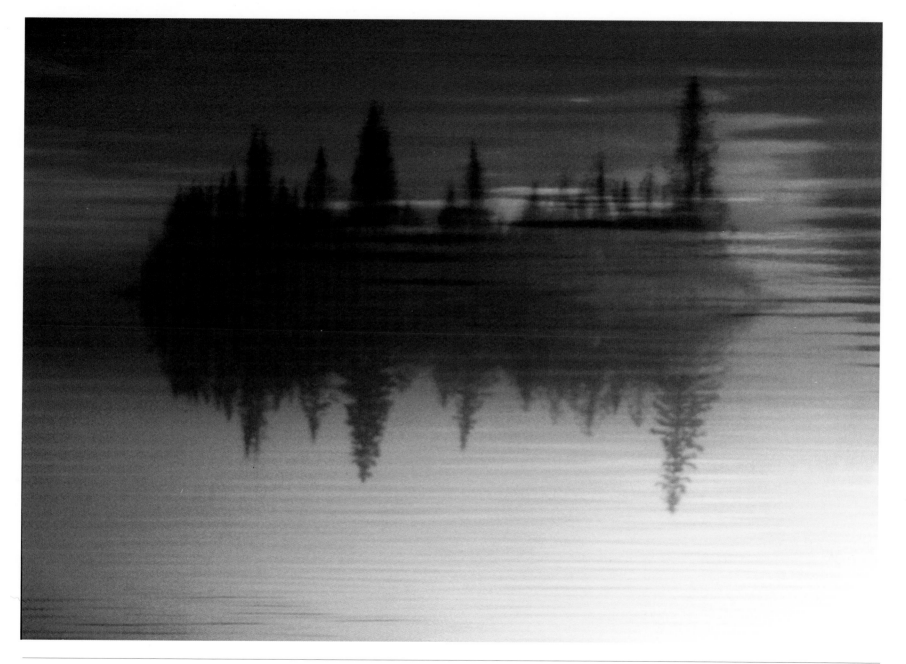

Nature's Essence

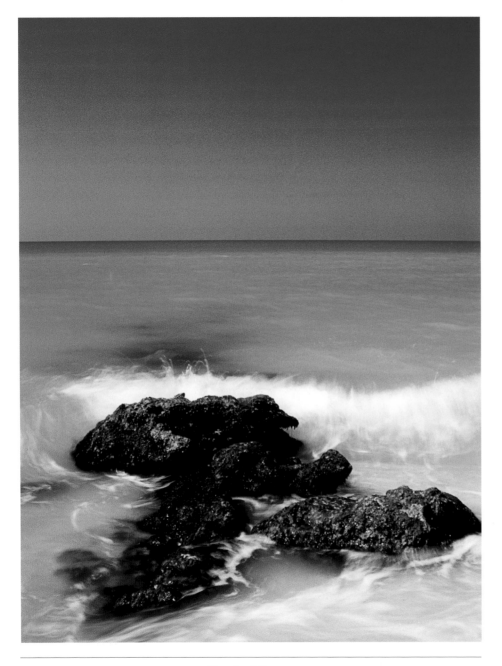

Tropical Dream

To experience the "catch of the day" is visual poetry. I'm not talking about the featured selection on a menu at your favorite restaurant. I am referring to the enchanting crystal seas that meet the land, sometimes calmly and at other times with violently pounding surf. A friend challenged me years ago saying I couldn't stay in one place long enough to enjoy the moment. I do like to explore, to adventure and discover unknown territory, but on a nice warm winter day, I got a campsite on the beach at Bahia Honda State Park in the Florida Keys and what I really did was accept the challenge—without realizing it.

The hours when the mind is absorbed by beauty are the only hours when we truly live.
Richard Jefferies

I awakened early, remembering the 30-60-60-30 rules learned early in my photographic pursuits. I was told that thirty minutes before sunrise, sixty minutes after sunrise, sixty minutes before sunset and thirty minutes after sunset were the best times for painting with a lens. I walked through a path in the sea grass with my tripod and camera and set up residence on the sandy beach. The background provided by the morning music of gulls and breaking surf, set the stage for the pink-streaked clouds before the curtain of a new day started, with the sun breaking the horizon.

Soon out of darkness came the morning light. The aqua-blue water glistened with the new day's sun. I dreamed to the rhythms of the waves as they lapped on the shore. As light changed and the heat increased there were fewer birds. Five dolphins performed a ballet for me to enjoy as the scenes changed throughout the day. The gull-winged birds returned in the afternoon to clean up food on the shore deposited by the mollusks swept ashore. I, too, got involved looking for that perfect seashell with coral patina, not in competition with, but in cooperation with my late afternoon companions.

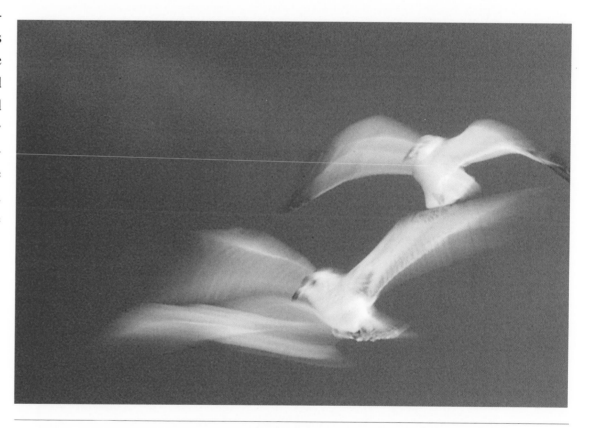

Beach Patrol

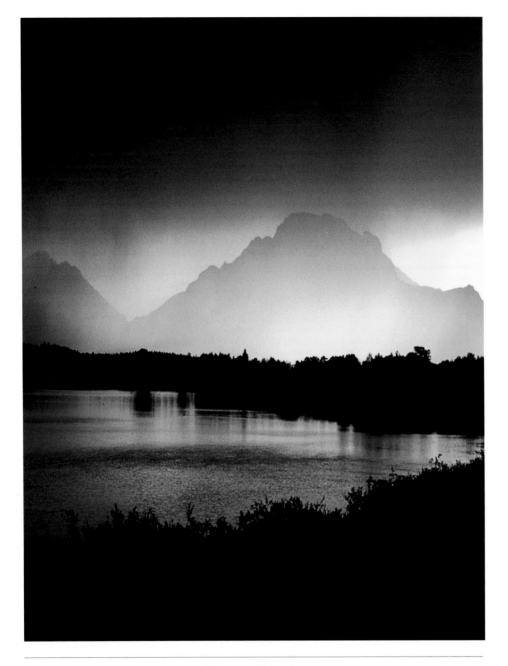

Summer Cleansing

As the sun lowered for its nightly rest, the glow of the rising half-moon appeared on the water. Clouds were painted purplish hues as the canvas of the last act of the day was nearing its close. I sat, waded, strolled and sat some more while savoring all that Mother Nature had to offer. On this day, I discovered that staying in one place was not at all challenging, after all.

On the last night before leaving Grand Teton National Park in the summer of 2001, I debated whether to visit my favorite place, one where I frequently watched the setting sun. However, a threatening sky, dark with clouds, and an approaching gusty wind, made me hesitate. The storm was approaching with sweeping clouds and lightning off in the distance.

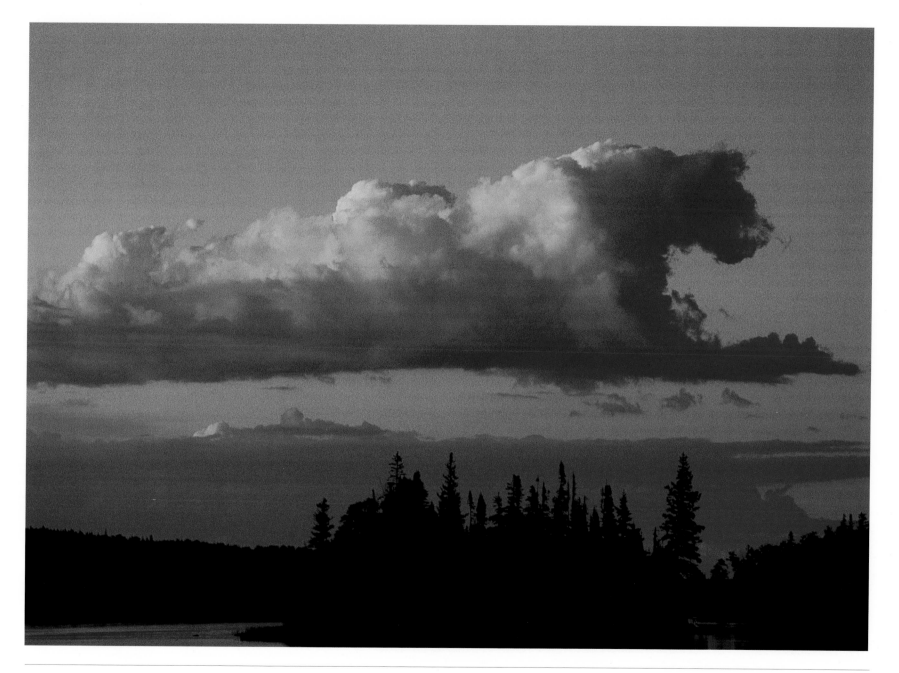

Leaping Lioness

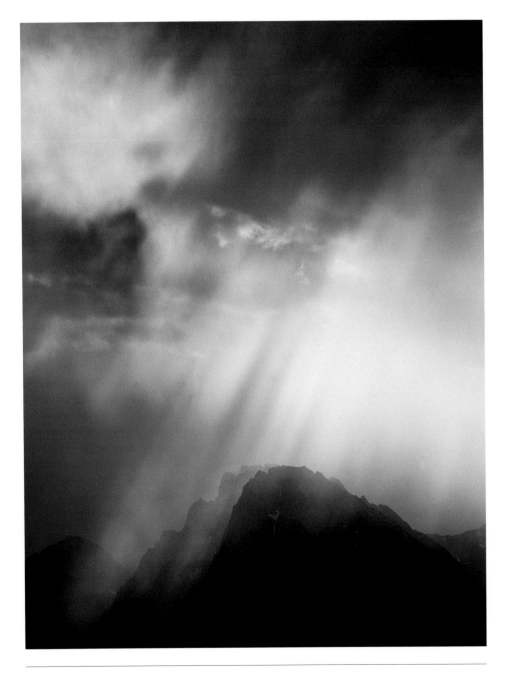

*For the man sound in body and serene of mind
there is no such thing as bad weather; every sky
has its beauty, and storms, which whip the blood
do but make it pulse more vigorously.*
George Gissing

Rays of Light

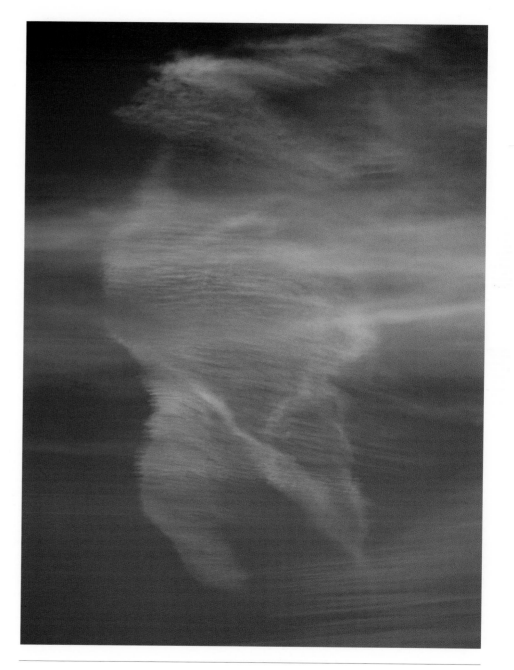

Deciding to visit my favorite place, I sat in my van, enjoying and yet fearing as the suspense unfolded, as if on cue. The storm passed over with winds rattling the van. The quickly passing storm headed to the Teton mountain range where the sun was getting ready to set for the night. Black clouds raced over the range blinding the pending sunset. Then a break in the clouds and a muted sun shone through the heavy rain as it cast its spell on the mountain peaks. The strands of streaking light highlighted the valley as if a star performer was yet to appear.

Waltzing Bear

The Grand Tapestry

The storm cleared and the sky opened up again, just before the sun started its final descent for the night. I got out of my ringside seat, stepped out into the now cool air and glanced over my shoulder as an eagle soared by. Then the finale began, a looping rainbow and then its shadow framed the lake and forest. A double rainbow graced the sky briefly as the sun made its final appearance! The panorama was a painted, glorious kaleidoscope shifting with nature's wayward brush strokes. Nature scapes are varied. Each day, nature presents a new canvas to be captured on the emulsion of film and the emulsion of the mind. Be a part of the landscape instead of merely a visitor.

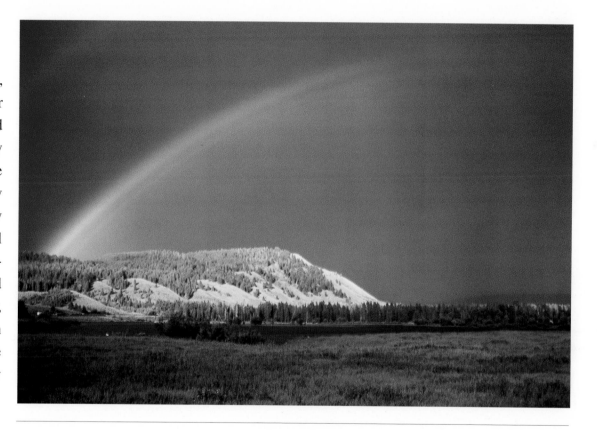

After the Rain

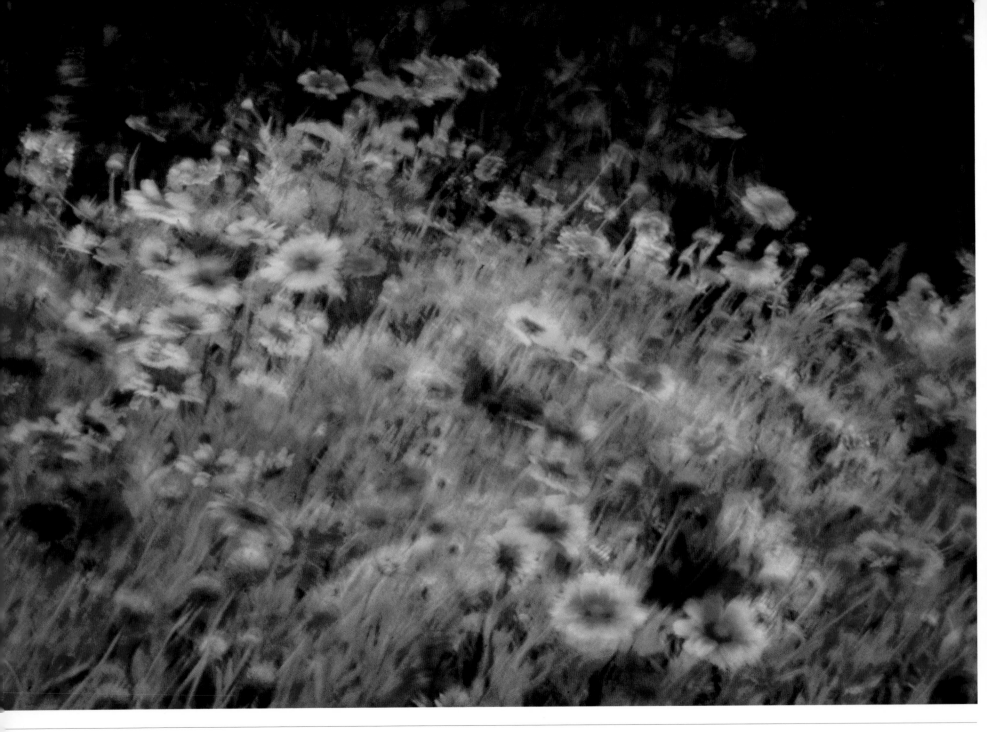

Painting with Wind

Artistry in Bloom

Where is the fountain that throws up these flowers in a ceaseless outbreak of ecstasy?
Rabindranath Tagore

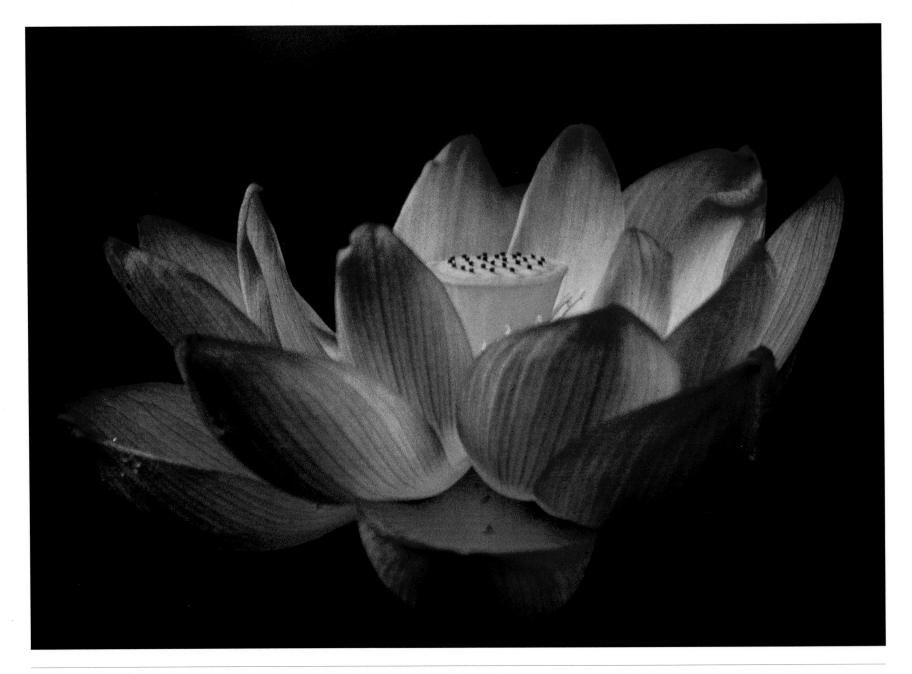

Floral Rhapsody

Imagine yourself walking along a tree-lined trail, which takes you into a world of wonder as you see forget-me-nots and sunflowers near the stream. Imagine the sound of a trickle of water flowing with a quiet melody, whispering soothing sounds. As you round the bend, you view the valley floor ahead with a carpet of colorful blooms swaying in the breeze. While you survey the multicolored show before you, you may also see in the distance a black bear and two young cubs mimicking their mother as she sniffs the delicate yellow and pink flowers, going from one to another. Nature's jewelry, pastel flowers some still curled in the bud and others open, leave you breathless as the drama unfolds before your eyes.

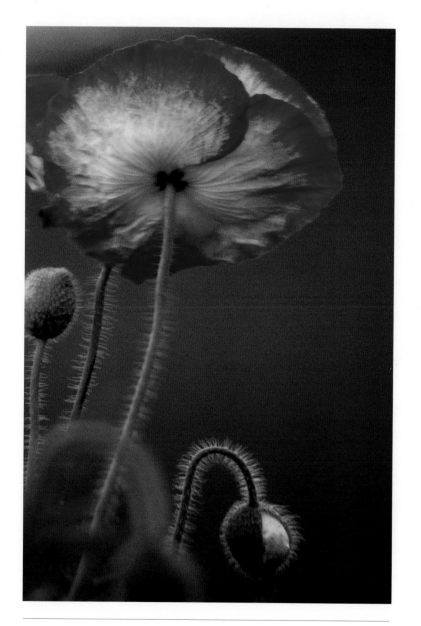

Dance with Me

Floral Paint

*Many eyes go through the meadow,
but few see the flowers in it.*
Ralph Waldo Emerson

I didn't imagine the three black bears in the flower field, but experienced it on a cool summer morning in one of our most outstanding national parks. Wildflowers grow in every hue of a rainbow. Their amazing beauty is but one of their features, there are many more. We can determine the onset of changing seasons by viewing the ever-changing carpet of blooms. In Yellowstone National Park, the first sight of a glacial lily signifies the beginning of spring. As one specimen fades it is replaced by another. After spending five summers in the Yellowstone area, I learned firsthand that the winter snow accumulations, the rate of snow melt, and the prevailing temperatures determine the onset of the flowering cycle, which varies from year to year. The brilliant display of spring wildflowers on the forest floor of the burnt forest signals the rebirth of the cycle and is one of nature's most valued gifts. Wild-

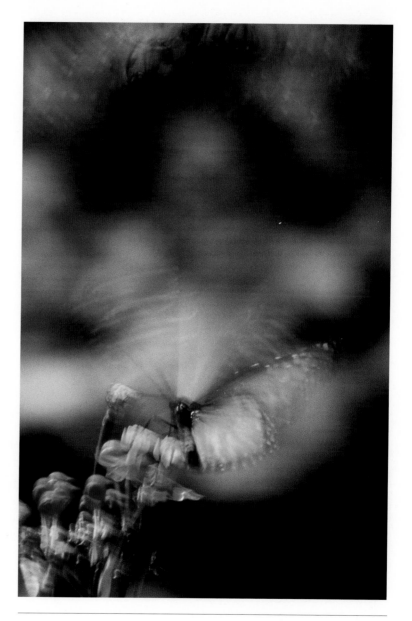

flowers are symbols of life and messengers of good will. Wildflowers are the palette of the earth. With their scent, texture and endless color, they stimulate our senses. With the change of the seasons and passage of time, flowers connect us to the rhythms of life. Mother Nature paints the landscape with vivid hues. Up close, wildflowers reveal amazing structural designs and exquisite patterns. Whether individually or collectively, flowers add patches of color and life to any scene.

Impressions in Nature's Garden

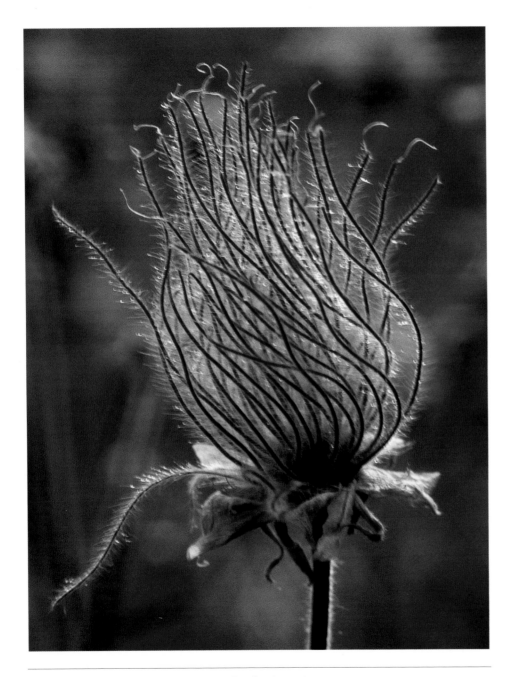

Perfection

Several years ago on the last leg of my hiking trek to the top of Mt. Whitney, at 14,000 feet and gasping in the thin air, I rounded a bend of a boulder-lined trail, part of a narrow switchback. In a crevice, shaded by the sun, was a lone sunflower seeming to grow out of a grayish broken rock. I stopped and wondered how in the world that little treasure, with such beautiful hues, could survive at that altitude and in that environment. But it did!

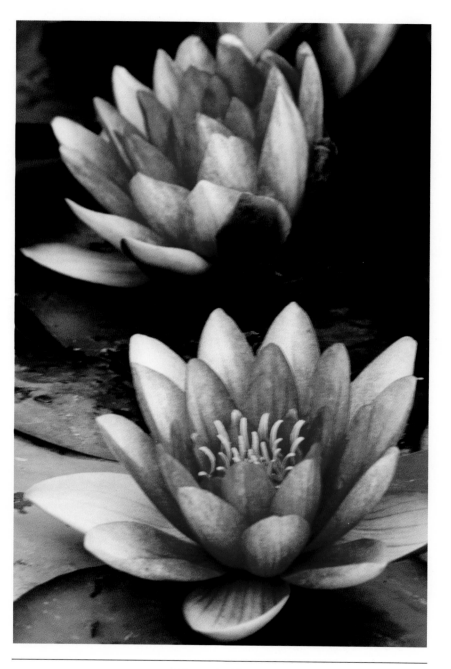

*The artist is the confidant of nature, flowers carry on
dialogues with him through the graceful bending of
their stems and the harmoniously tinted nuances of
their blossoms. Every flower has a cordial word,
which nature directs towards him.*
August Rodin

Nature's Bloom

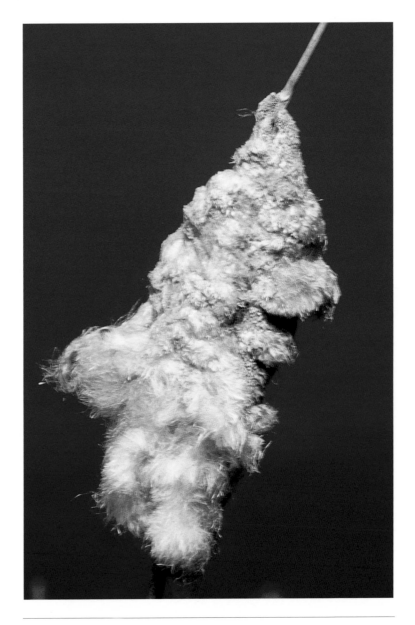

A Face in Nature

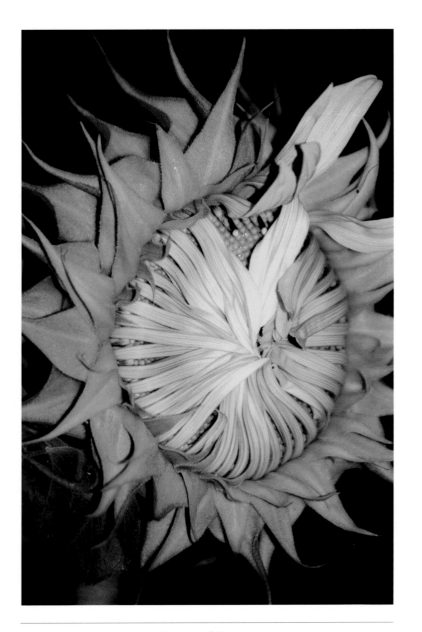

Seasonal Poetry

Wildflowers may be nature's first bathing beauties. Picture a field of sunflowers all facing the sun. They seem to rotate in unison to follow the path of the sun daily, maximizing their exposure to the sunlight.

Visualize a woodland teaming with colorful blooms while being brushed by the wind; picture seeing flowers that fly. You may not have considered butterflies as flying flowers; however, their colors, designs and textures mirror the flowers they grace. While hiking the green-choked trails in Isle Royale National Park, I stopped often to admire and photograph the beauty of the springtime orchids. While lying flat on the ground to get a better view, a butterfly landed on the blossom as if to say, "Good morning." The color of the butterfly mirrored the brush strokes of the flower. Wow! What a scene as the orchid and butterfly fluttered in unison! They spoke to me, not with sound, but with a beauty that shone inside and out.

The butterfly counts not months,
but moments, and has time enough.
Rabidranath Tagore

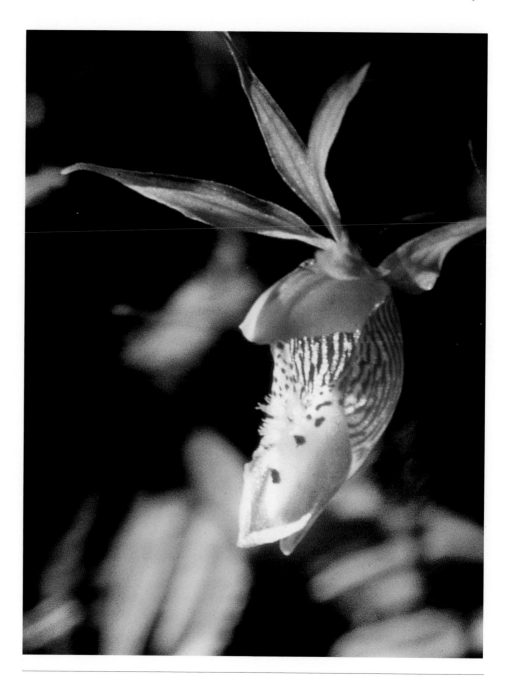

Dancing Petals

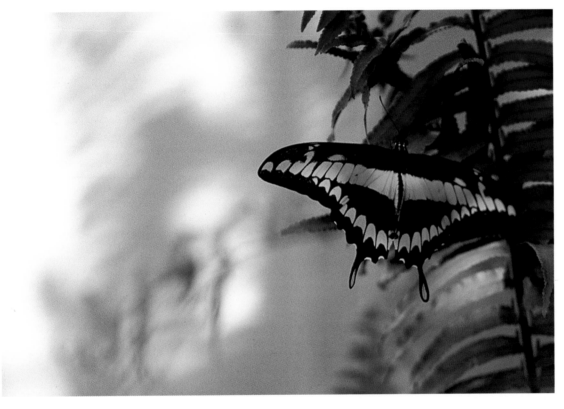

Giving Thanks

As I pointed my lens at the unexpected canvas presented to me, the butterfly moved to another bud. I missed it! I missed recording on film that split-second flower ballet. As I returned to camp, I walked several miles "with" or the butterfly walked with me, all the way back. From bud to bud, he seemed to rest while waiting for me to catch up. I set up my tripod several times to get a picture of my newfound hiking buddy, but to no avail—it would journey ahead of me each time. However, I did get to savor the unfolding drama and experience of hiking with a new friend—it was food for my soul.

While flowers provide a peaceful scene as we gaze at them, their rich colors, scents and shapes are invitations to their pollinators—birds, bumblebees and butterflies. It seems America's largest gardener, a provider of flowers as tiny as a pinhead and sentinels to the season, also has a master plan to provide these special treasures for every season. The butterfly sips the nectar, the liquid gift of the flowers, while the bee gathers pollen.

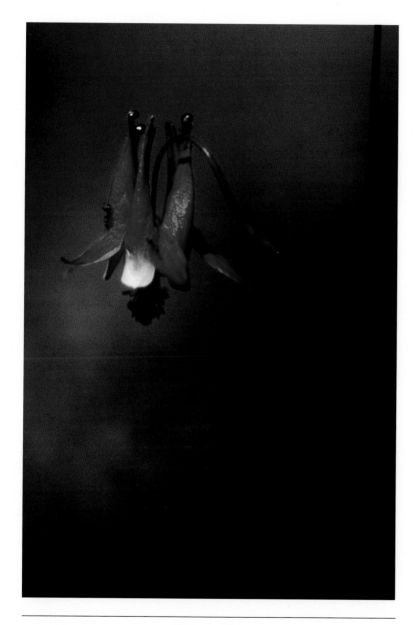

Summer Joy

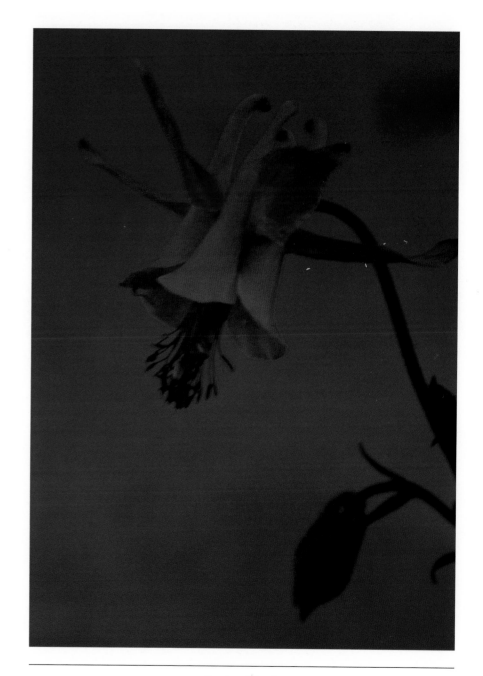

Spring Blush

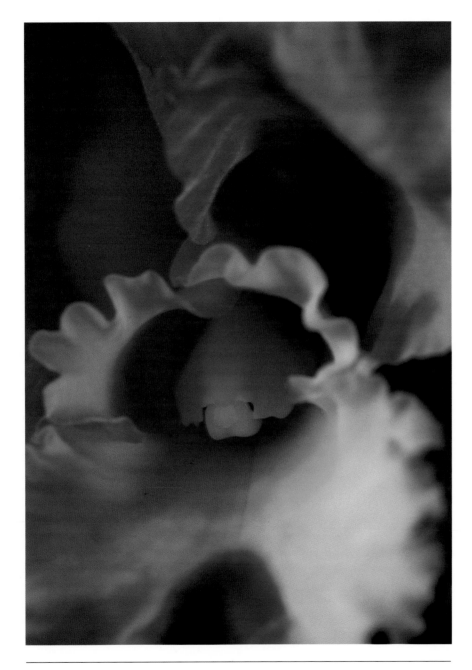

Swim with the Flow

But the bee . . . gathers its materials from the flowers of the garden and of the field, but transforms and digests it by a power of its own.
Leonardo da Vinci

Through the ages, people have ascribed countless meanings and symbolisms to flowers. As children we knew the meaning of holding buttercups under our chin and predicting the future, like drawing straws, or plucking petals one by one from a flower—"she loves me, she loves me not." Holidays are observed with flowers that fit the season. All fifty states, all of Canada's provinces, and many countries around the world have officially adopted floral symbols as part of their identity. When I think of the Netherlands or Holland, Michigan, the first image that comes to mind is the tulip. Yet tulips are grown all over the world, representing beauty and grace. As far back as 1893, a flower was designated as the official flower of a state when Minnesota adopted the lady slipper.

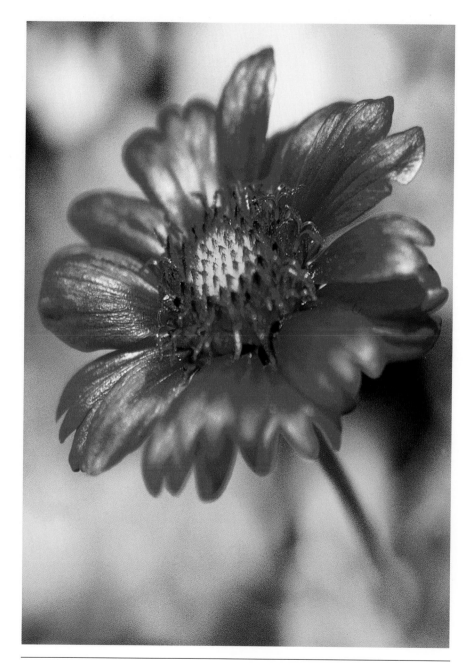

Painted Splendor

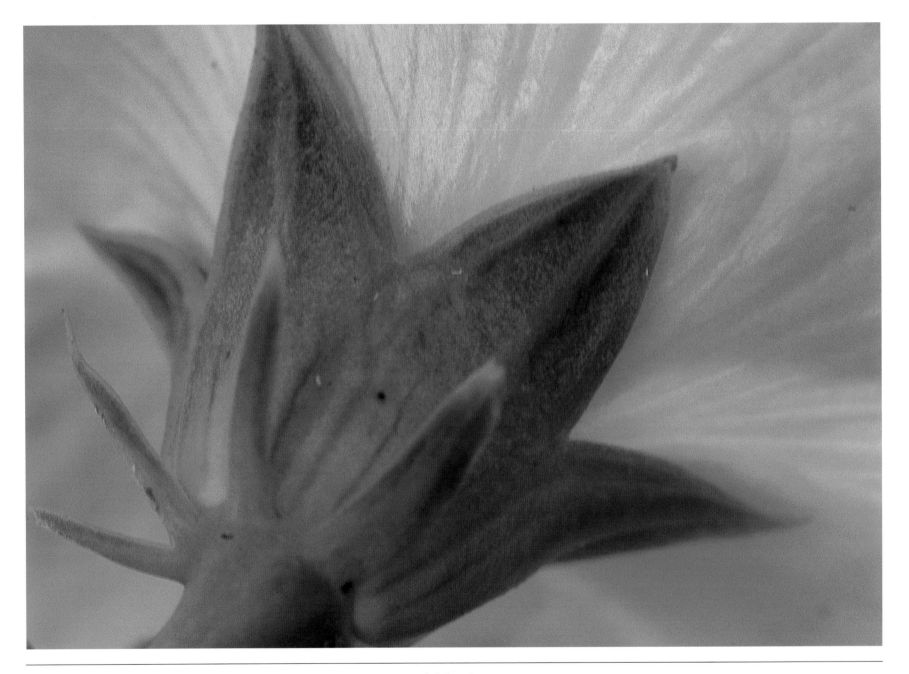

Celebration

Artistry in Bloom

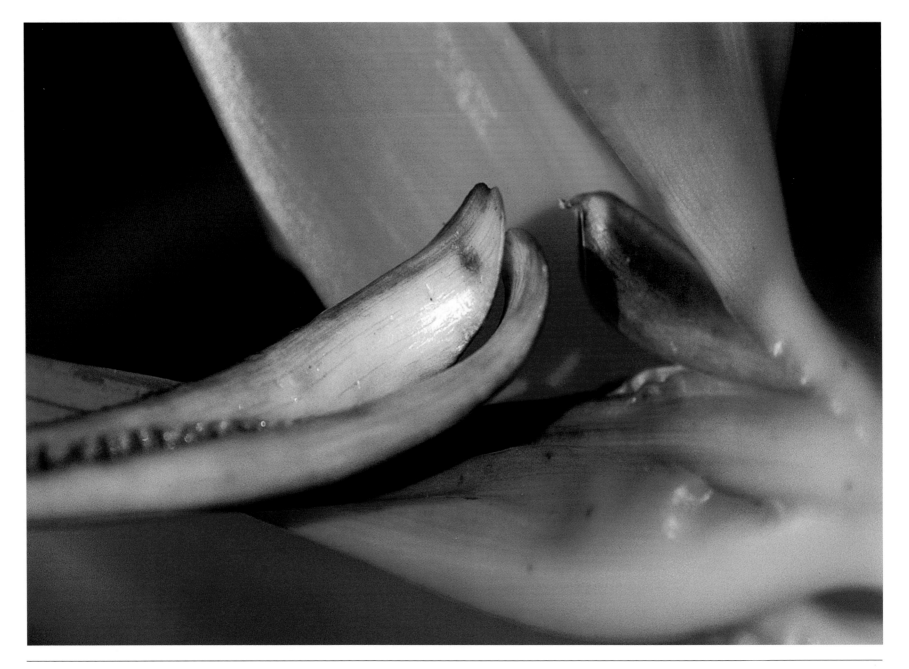

Friends

Flowers are symbols of communication. With the most common communicator of love, the rose, every color has a special meaning. Yet when one is not bold enough to say it with a rose, other flowers such as gardenias, lotus or peach blossoms are given instead, each with its own hidden meaning of love. A child picking a dandelion and running to give it to a friend or parent is one of the simplest, yet sweetest, expressions of love. As adults, we treat dandelions as weeds, a menace to one's green lawn. I wonder if we would look at this wildflower differently if it were rare. If they were endangered and difficult to propagate, there would probably be dandelion clubs formed to protect and preserve them!

Flowers, whether cut, arranged, planted or wild have their own language. We feed them and nourish them, touch their delicate petals and leaves, smell the fragrance and perfume they emit, and marvel at their colors, shapes and textures. A flower's artistry is endless and magnetic, each one unique with its own expression.

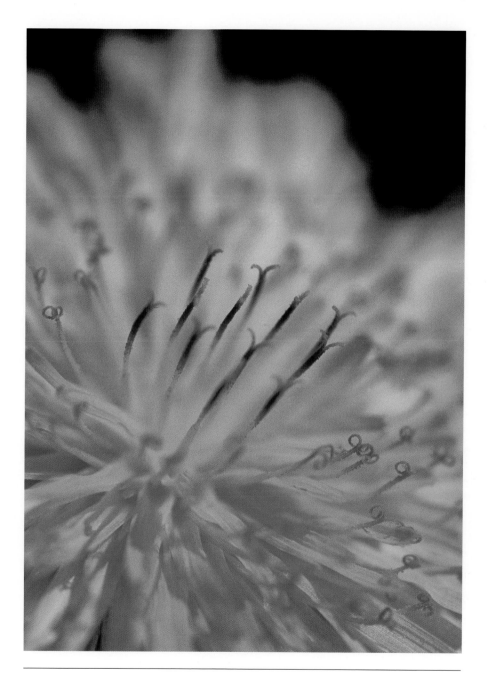

Silent Beauty

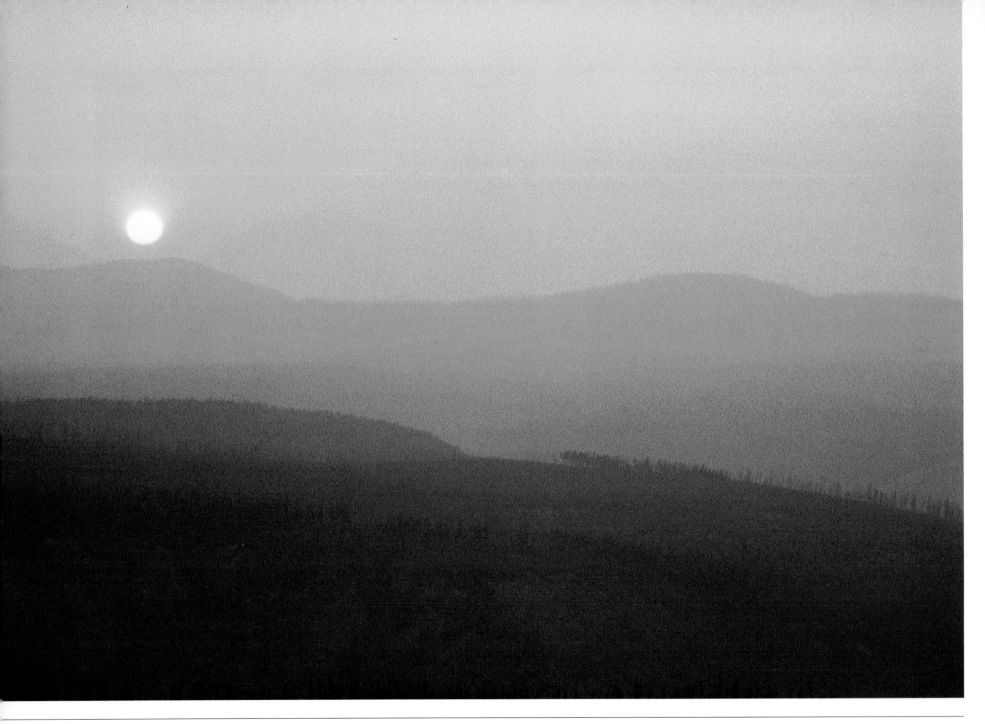

Smoky Twilight

Fire as the Artist

The love of nature is a passion for those in whom it once lodges. . . .
It is a furious burning, physical greed,
as well as a state of mystical exaltation.
Mary Webb

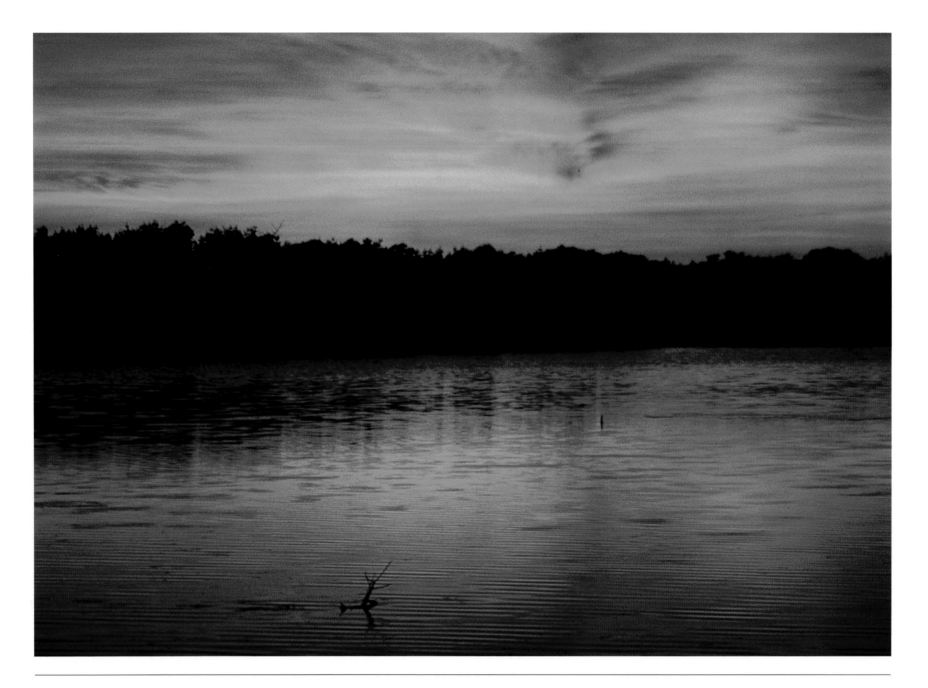

Burning Glory

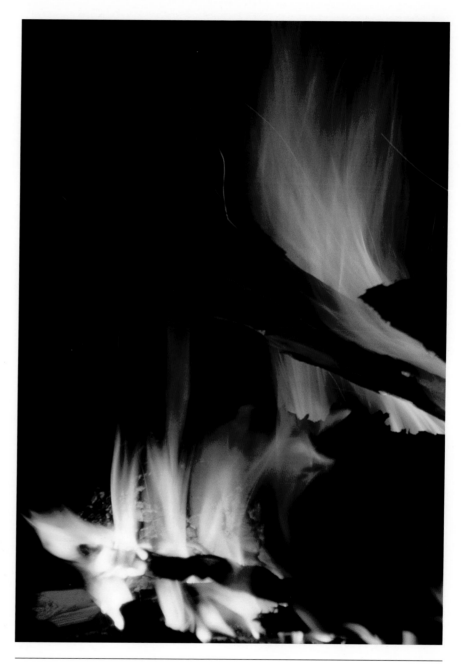

Human beings have been both fascinated and frightened by fire for centuries. While fire brings heat and light, it also creates death and destruction. Fire is as much a part of nature as water; it is a basic environmental factor. We are drawn to water in its many forms as rivers, falls or beaches, rather than avoiding it, despite the potential for devastating floods. Fire, no different than water, has been a natural directing force on the earth we inhabit.

Is there anything, in fact, more beautiful
than a leaping, luminous flame of fire?
Or anything more useful, when it warms
us, heals us, cooks our food? Yet, nothing
is more painful when it burns us. Thus,
the same thing applied one way is harmful,
but when properly used is extremely beneficial.
It is all but impossible to numerate all the
good uses to which fire is put throughout the world.
St. Augustine

Crackling Warmth

Fading Palette

The flames of a fireplace flicker and dance in orange, blue and yellow before our eyes. Crackling, sizzling, burning logs in a campfire glow in luminous colors, while giving warmth on cool, star-studded nights. Holiday pyrotechnics, known for their loud discharges and spectacular appearance, provide enjoyment for young and old alike, and clouds set afire by the rays of the rising or setting sun are examples of the awesome beauty of fire. However, when we think of fire the first thought may be a wildfire with its power to turn vast forests into desolate moonscapes.

Ashes are the work of a moment,
forest the work of centuries.
Seneca the Younger

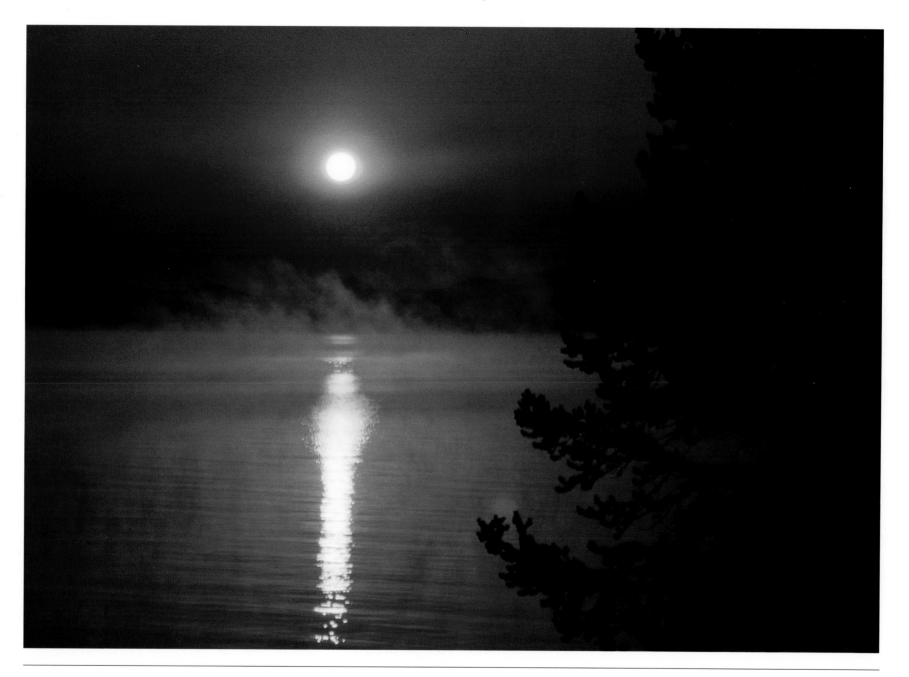

Tumultous Grandeur

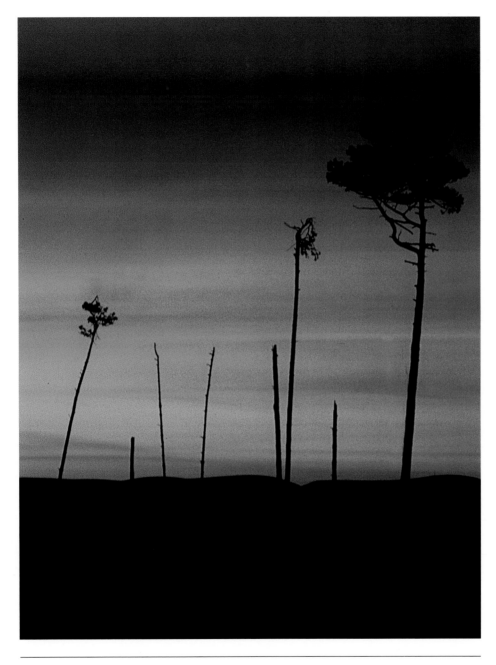

Rays of Life

Much has been written about the fires that swept through a rain-deprived national park in the summer of 1988—the historic Yellowstone National Park fire. In short, 36 percent of the park burned (793,880 acres), $120 million was spent fighting the fires, 25,000 people were employed in these efforts, and about 300 large mammals, primarily elk, perished. The 1988 forest fire created a mosaic of burns, partial burns and unburned areas. The first time I visited Yellowstone National Park, in 1995, I witnessed blackened spires and charred remains. While hiking the many trails in the valleys and hillsides, I listened to the wind rustling amongst the charred trees; I would see a snag fall and hear its impact; then another and another until, one by one, almost like falling on cue, they create a domino effect— sometimes five, eight and up to fifteen at a time. As I covered my head and found a safe spot to view this mysterious phenomenon, I marveled at the action in the otherwise sparse forest.

I also witnessed the power of nature to heal and restore the land to its natural function. Nature, indeed, planted new trees. Their paintbrushes were still busy drawing a new mosaic. The forest floor had rays of sunlight shining on it; lush new nutritious grasses, green seedlings and colorful wildflowers were growing! The fire and weather turned burnt tree trunks to a silver patina. New vistas were opened, birds and animals found new habitat. Nature's pantry, replenished because the mineral-rich ash soil provides additional food sources for all the critters that make Yellowstone National Park their home. Nature, indeed, heals wounds; a new vista gradually replaces the subtle indescribable beauty of the forest fire.

While the burned trees provided subtle beauty amidst the springing of a new forest, as a nature photographer I documented on film the artistic treasures from the blackened spires and charred remains that dot the black and gray landscape of Yellowstone. My pictures appear in the chapter, "Relics 'Midst the Ashes," which is included in my second book *Nature's Artistry*.

Celestial Fire

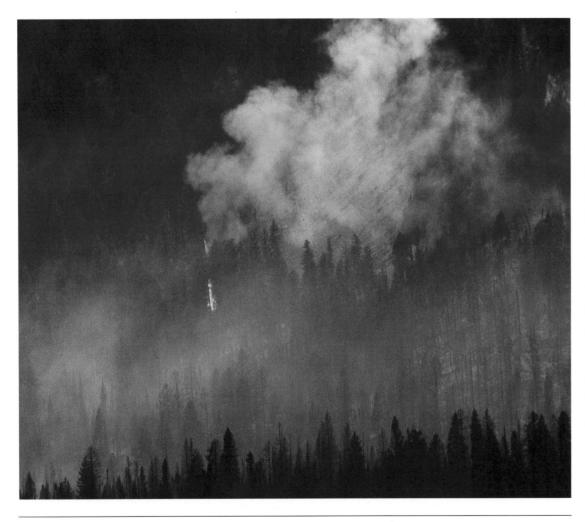

Blind Fury

In the summer of 2000, however, I witnessed with my eyes and lens the effects of the wildfire in the Yellowstone ecosystem. I saw fire racing across the landscape, fire climb trees like a black bear cub, and smokestacks billowing fire and yellow smoke in the clear sky. I experienced first-hand the scent of smoke that tears the eyes and chokes off fresh air. I talked with fire jumpers and visited their camps where they replenished their bodies with food and rest. While the fires were small compared to 1988, I got a clearer visual impression of the three-part play of fire—the landscape as it was, the devastation during and the resulting aftermath.

At the end of a work day, sitting near a campfire for warmth, swapping tall tales and feasting on 'smores on Isle Royale National Park, I wondered if I could further capture "fire art" through my lens. I recalled that before stoves, kilns, and the furnaces to heat our homes, the campfire was once a way of life. The temporary sculptures of red embers of the crackling fire and a bed of hot coals proved to be a worthy challenge. I tried not to get in the way of the whitish smoke as the wind continued to shift. My fellow workers wondered why I was taking a picture of the artistic flare since my intention was to capture the essence and imprint of the flaming fire itself, and to smell the smoke, which reminded me of the incense of an autumn bonfire that warms the soul.

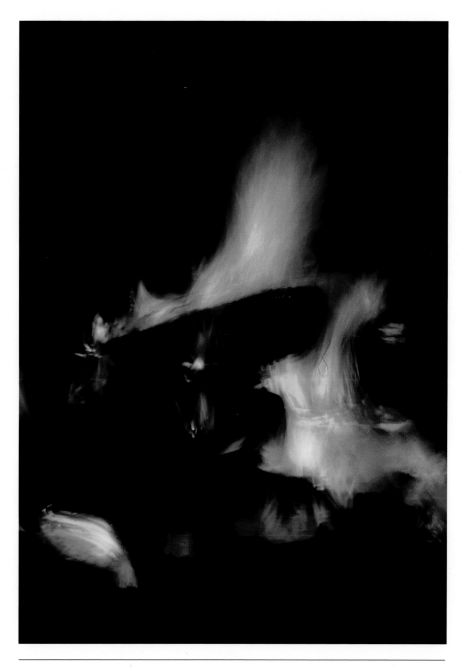

Camp Whispers

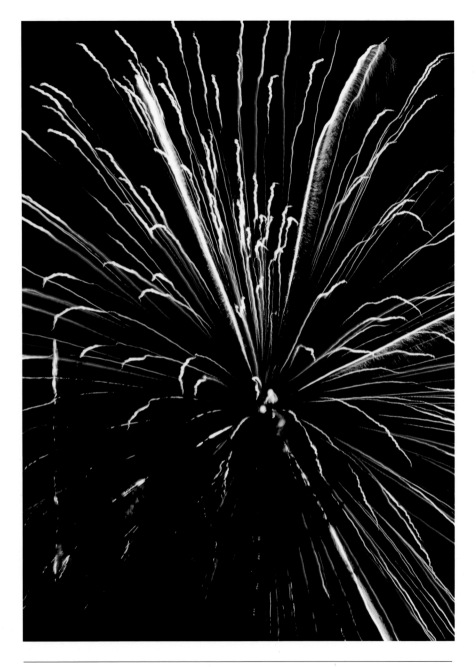

Celebration

Yet, I still wonder how anything so destructive can still have beauty about it. I still have moments engraved on my mind—the most vivid images of pyrotechnics several years ago when I was caught in a massive traffic tie-up en route to my armed forces duty station in Washington, D.C. The annual July 4th fireworks filled the skies with dazzling colors as they silhouetted the beautiful national monuments on the lawn of the Mall. The brilliant fire in the sky continues to illuminate every Fourth all over America for us to enjoy.

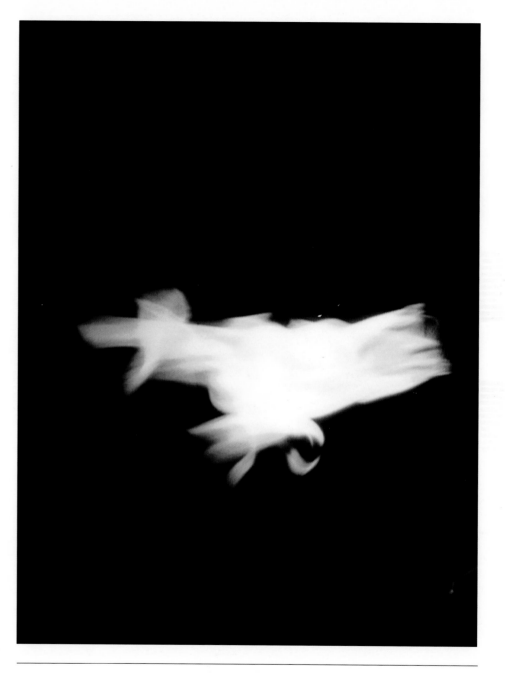

Flaming Chicken

Fire is a source of poetry, song, essay, cliché and art. For me it has become a source of photographic art. As I explore through my lens, I am amazed at the discoveries yet uncovered. At one time or another many have seen torch lamps popular for luaus, pool parties and evening receptions. While observing a Chinese New Year celebration and parade, my eye caught the flickering flame of torch lamps lining the parade route. The brisk, yet warm, wind played on the flame. The animation of the flame kept changing while I focused my lens on the firelight. The resulting images, mostly abstract, were colorful and pleasing to me. The running chicken is my favorite; a flaming beautiful subject on a fire canvas painted by the wind. These discoveries spark my imagination and fuel my soul. I am constantly amazed at the varied expressions of design and beauty found in the ordinary. Nature paints a picture every moment that stoke the fires of my imagination.

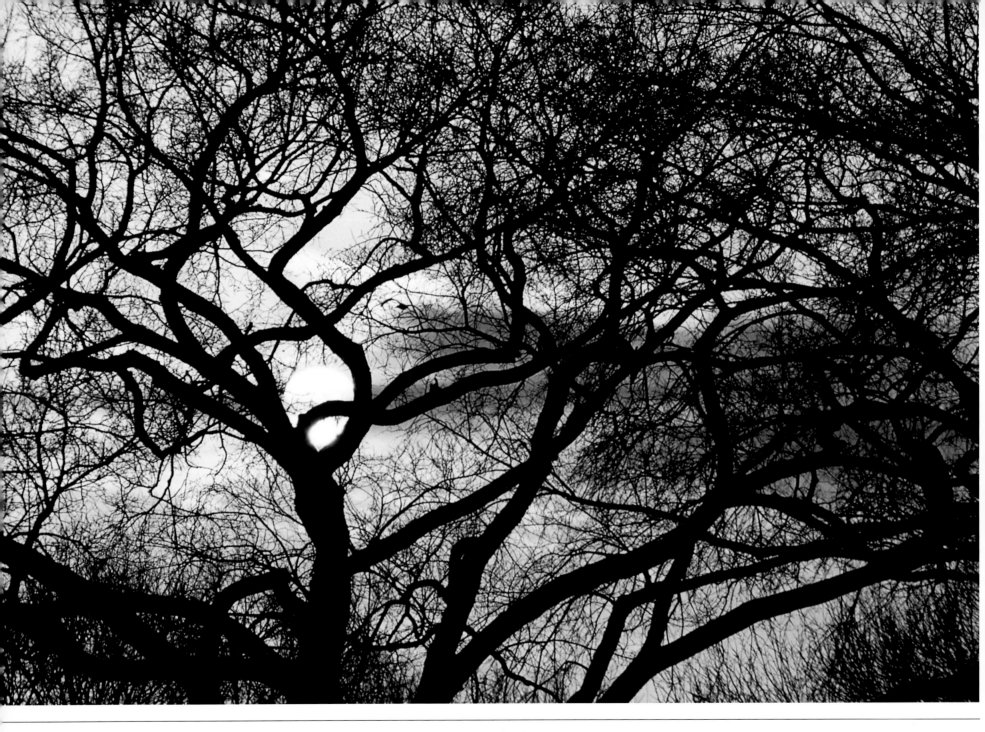

Evening Splendor

From a Seedling

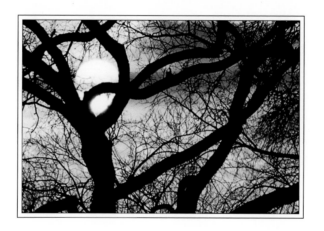

*Remove nothing from the forest except
nourishment for the soul, consolation for the heart,
inspiration for the mind.*
Unknown

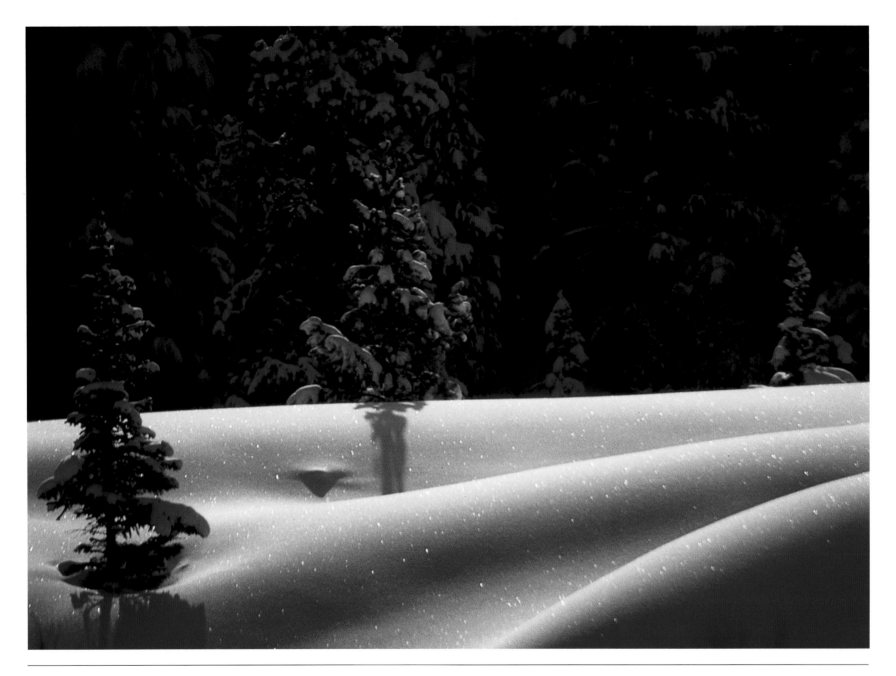

Snow Blanket

Imagine a treeless landscape. What would it look like? How would you feel? How would you smell blossoms? Would nature's music be different? What other resource would provide as much as a tree? Imagine for a moment—a landscape without a tree.

From a seedling a tree matures and a forest flourishes. Over time a sapling will filter the air we breathe, purify our water, provide shelter for animals and man, be a source of fuel and heat and its roots will reduce runoff and erosion. Over time it will be a source of many products including nourishment for the body and solitude for the soul.

I am struck by the fact the more slowly trees grow at first, the sounder they are at the core . . . such trees continue and expand with nearly equal rapidity to an extreme old age.
Henry David Thoreau

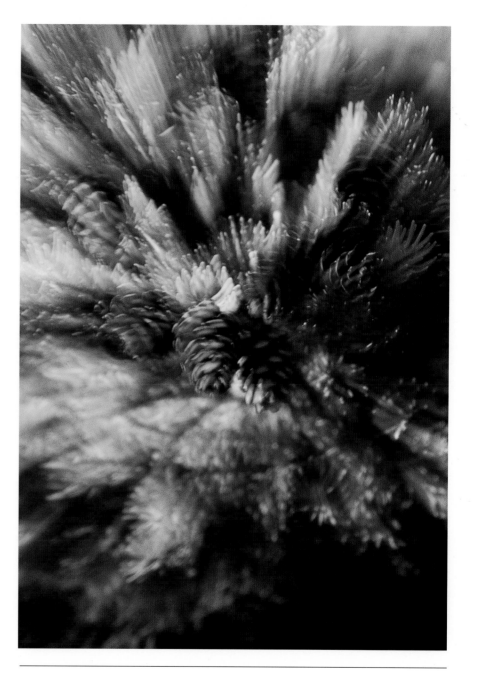

Bursting with Life

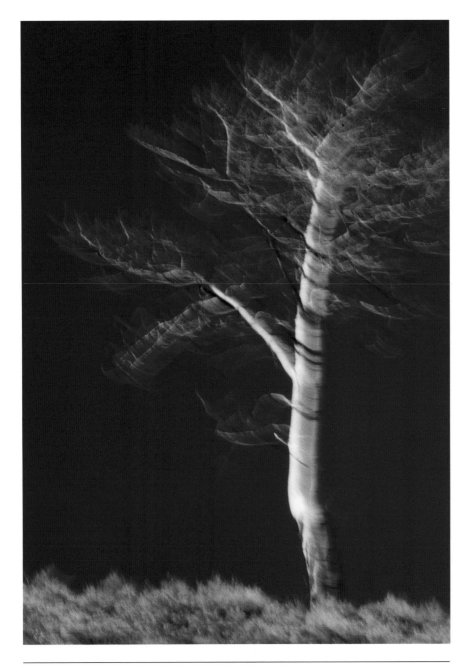

Silver Breeze

Over time a tree will emerge with beauty all its own. The sun will glisten through the branches; the blushing shades of leaves will provide shade. The birds sing their chorus and perhaps a robin will nest her first offspring. Over time, a tree cleans the air while sharing its pleasant fragrances—the perfume of its blossoms and flowers. The leaves will intercept the rain and snowfall, and a tree will reach for the sky, spread its branches like wings to capture the whisper of the wind and share the melody. Each leaf will expose light, patterns and details of beauty like a stained glass window. A tree will become a barometer of life almost sharing feelings and moods. It will become a time clock, ringing in a seasonal cadence with its own rhythm and renewal. Yes, over time a tree emerges anew from what was once a seedling.

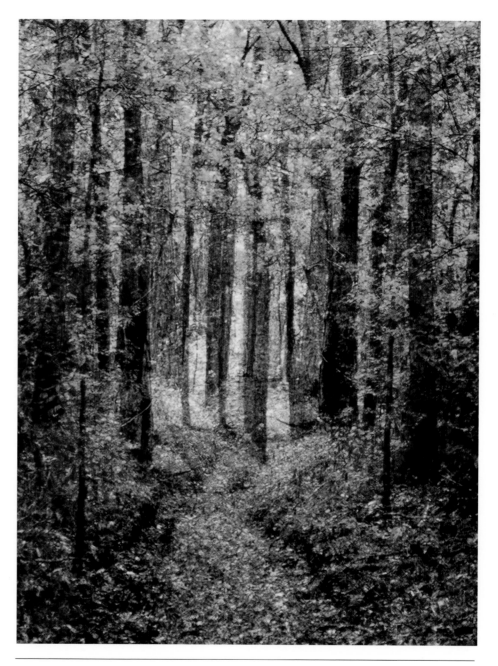

A forest emerges. It will be seen, smelled, tasted, felt and heard. Raw materials will be harvested. There will be a place for quiet and solitude, a place in which to find oneself as well as a place in which to become lost. Over time a community will emerge. A forest community grows taller and lives longer than man. It is an interconnected community of animals, plants and organisms sometimes too small to see with the naked eye. The soil, water and minerals are the life of the community. Forests, small and large, young and old alike, are all different, dependent upon weather, climate zone and soil. A forest will recycle itself, making way for a new one to emerge.

We have nothing to fear and a great deal to learn from trees, that vigorous and pacific tribe, which without stint produces strengthening essences for us, soothing balms, and in whose gracious company we spend so many cool, silent and intimate hours.
Marcel Proust

Carpet by Leaves

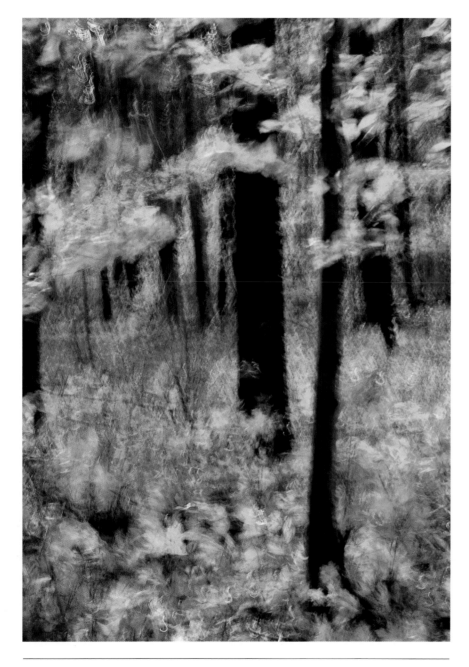

Autumn Dress

I have explored the cycle of the tree from an emerging sapling to a forest through my camera lens. In the woods, with nothing but the pleasure of birdcalls and my own curiosity, I have found artistic beauty—from a single leaf to the grand landscape in each season. In the spring as the world awakens, I have captured tree blossoms dancing in the wind and new growth on conifers. In the summer, I have watched blossoms transform into oranges and grapefruit in my backyard. In the fall, the dress of the landscape changes, vestments of gold, crimson and orange paint the countryside similar to the patchwork of a quilt pattern. In winter, I have discovered the season as trees reveal their dark branches similar to the strokes of a master calligrapher. It's also the season when the colors of fall take on a costume of winter's snow. Watching the seasons shift provides a new canvas as the tapestry of the landscape changes.

The invariable mark of wisdom is
to see the miraculous in the common.
Ralph Waldo Emerson

While lugging my camera gear on hiking trips in the Grand Canyon, camping in the White Mountains of New Hampshire, or camping on the seashore of the Florida Keys, I have not only recorded images, but I also tried to capture the experience of the moment, the feeling, the awe of that split second. In order to do this, I've learned to slow down and be patient. By seeing, smelling, listening, and touching the seedlings of the forest, I have discovered its deep and mysterious beauty as well as the individual physical characteristics of the tree. I have concluded that a forest is really a pantry carpeted with a leafy, mossy sponge-like material. Each tree is an open cupboard, a storehouse of food for innumerable species of flora and fauna. Nature's buffet, from the root of the tree to the tip of the tallest branch, makes the forest community possible.

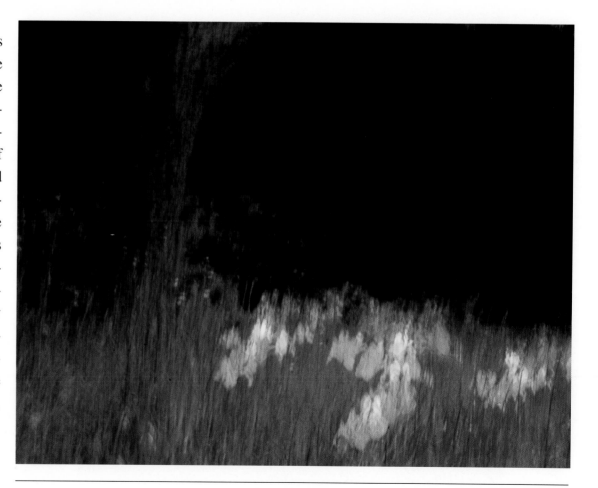

Floral Medley

Peace in the Forest

Several years ago I biked through the redwoods of northern California and I remember how minuscule and breathless I felt compared to the giant trees of the forest. I saw the redwoods, but did not really experience them. Several years later I had a chance to visit the ancient forest again and took more time to explore, hike, sit on a lying snag, and touch those giants! I still remember the silence, the stillness and peace as I roamed beneath the canopy in nature's cathedral. The dampness, the moss-covered snags and the enormous ferns, catching the rays of the sun, felt like heaven on earth.

As I continued my journey south, I came upon a lumber mill and passed by. However, I had never been to a lumber mill, I turned around and headed back. I wanted to see not only how a mill worked but also to determine how much of the tree was actually used. From the unloading of trees, to the pre-cut rinse and bath, to dropping them on the conveyor belt, to the initial cut with a six-foot diameter saw blade, to the slicing, sorting and wood quality checkpoints, I was not only fascinated by the process but reassured that the whole tree is used for some purpose, even the sawdust and twigs left on the floor.

People have used trees to make wood products for centuries. Settlers used trees for firewood, simple tools, fence posts, railroad ties, shelter and many other uses. By-products or waste—sawdust, bark and wood scraps—were burned or left behind. After my tour of the lumber mill, I was surprised to learn the many uses made of the whole tree. We take for granted so many products used today, not knowing from what source they came. Shatterproof glass, photographic film, wallboard and crepe paper are made from pulpwood. Varnish, medicine, paint, printing ink, and glue are produced from sap. Sawdust is used in bedding for livestock, making plastic, aiding in the storage of ice, and in the manufacture of composition board. Stumps produce veneer; bark produces flavoring oils; foliage contributes to pine scents, potpourri and decorations. And from logs come toothpicks, musical instruments, toys and building structures. We can also thank the seedlings that mature into fruits and nuts.

A seed hidden in the heart of
an apple is an orchard invisible.
Welsh proverb

Evening Whispers

Vanishing Moments

From the seedlings reforesting Yellowstone National Park, to the lone tree hugging the rock above the tree line in the White Mountains, to the vastness of trees in the rain forest of Alaska, I have seen the beauty, smelled the exhilarating scent of the conifers, and listened to the soothing sounds of the trees on the landscape. I have played, worked and been fascinated by trees. I climbed them when I was young. I picked sour cherries and green apples for baking. I built tree houses in an old tree on an abandoned lot. I pressed autumn leaves. I built workbenches and furniture for daily use. I have used logs to heat my home. Underlying these activities is my love of trees. My photographic adventures remind me of the numerous benefits as well as the beauty and nourishment nature provides from the body and soul of a tree.

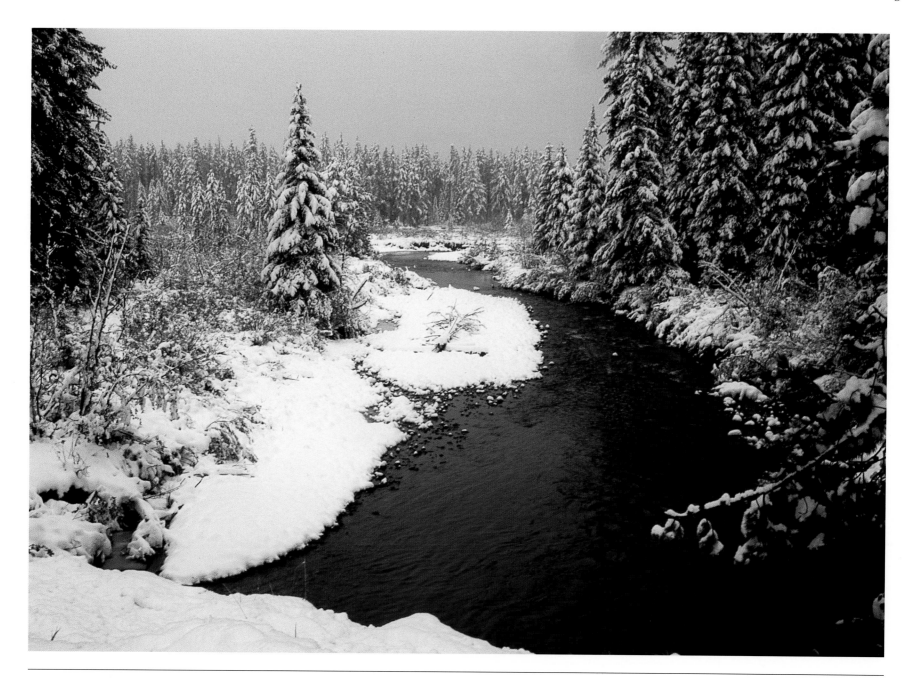

White Showers

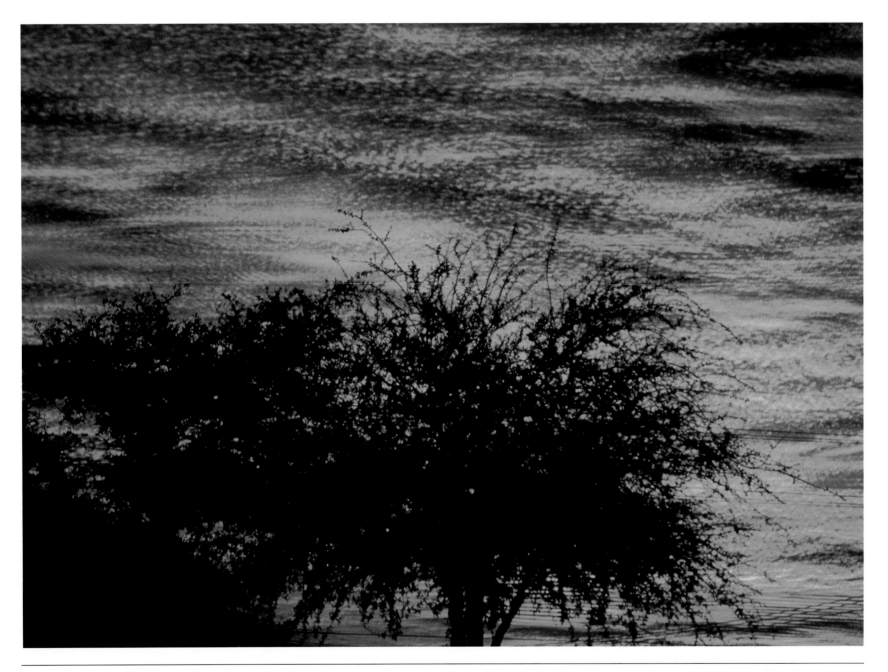

Evening Bounty

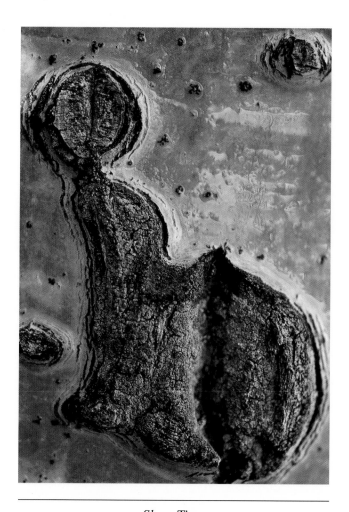

Show Time

Standing Tall

Imagine again . . . a treeless landscape . . . and thank Mother Nature! Thank her for providing a seedling so trees mature and a forest flourishes.

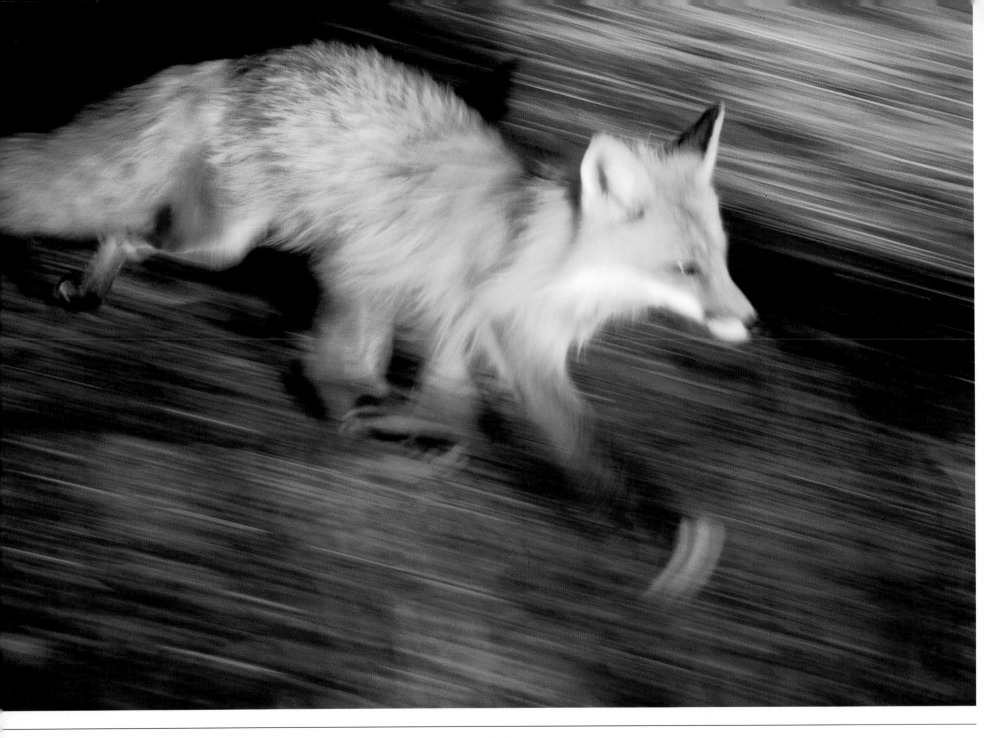

Camp Thief

Wildlife: Expect the Unexpected

Animals are such agreeable friends—
they ask not questions, they pass no criticisms.
George Eliot

Rush Hour

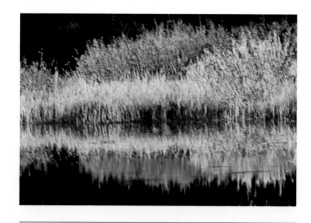

Solitude

The sun had begun its descent on a crisp clear night as I knelt with my camera focused on the pond ahead. Wildflowers and tall reeds reflect their magnificent colors on water smooth as glass. I savored the moment as the sun, filtered by the clouds, floated aimlessly lighting the reflection with the silence only being broken by birds looking for their nighttime snack. The scene combined peace, solitude and serenity.

> *To the attentive eye, each moment of the year has its own beauty, and in the same field, it beholds, every hour, a picture that was never seen before, and which shall never be seen again.*
> Ralph Waldo Emerson

At the same location the previous night, wonderful light reflects a mother elk and her young calf walking and swimming across the pond. I heard the rustling noise in the woods warning me of wild animals in the area. Sure enough they emerged into my picture frame as if on cue. I thought I must return again to find the scene without of any wildlife breaking the clear sheen of the water. It would be a powerful image representing the spirit of nature.

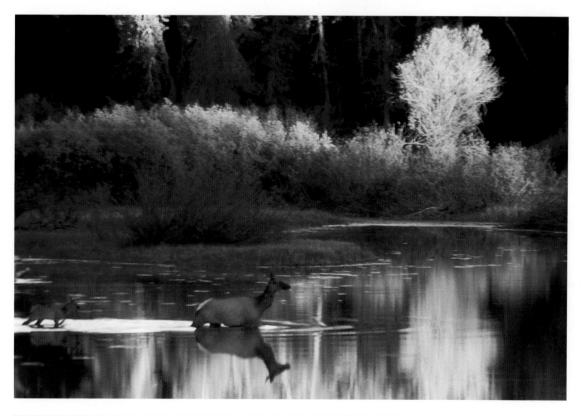

The Crossing

83

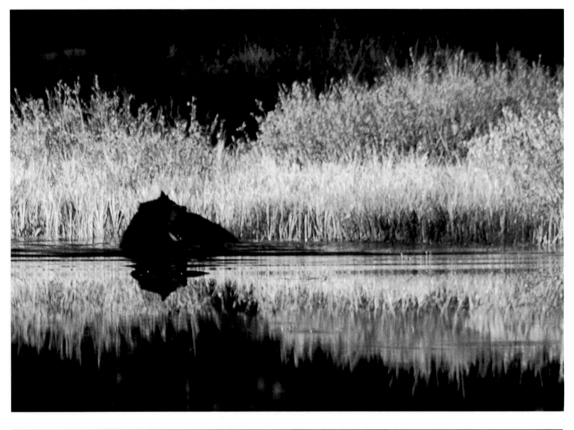

Unexpected Visitor

I did return the next evening and the pond was free of animals and waterfowl and the stillness of the waterscape was what I had envisioned. As I captured this moment with my camera, on the fringe of the pond, a black bear with a beautiful clean sheen appeared at the edge and dove in, breaking the silence. I was stunned as adrenaline pumped through my body, surprised that I didn't hear the rustling noise, warning me of his presence. I was closer to the bear than to my car where my bear spray was safely stored! The bear took his swim, stopping long enough to stand and open his jaws, as if to say, "What a beautiful night." He swam to the opposite side of the once still pond, climbed up the short incline, shook his water-drenched body and off he went into the nearby woods. That experience left "paw prints" on my soul. A great reminder—in his habitat, I am a visitor, and must be prepared at all times.

Bears are made of the same dust as we,
and breathe the same winds and drink
of the same sun, his dwellings are
overdomed by the same blue sky,
and his life turns and ebbs
with heart-pulsings like ours. . . .
John Muir

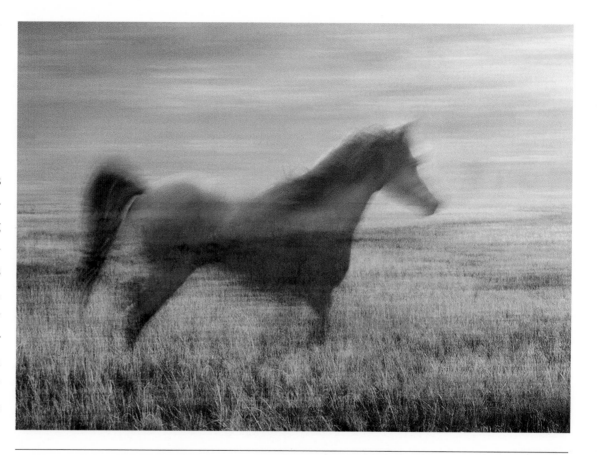

Happy Trails

Experiencing animals in the wild stirs emotions of excitement and fear while giving way to wonder and mystery. Seeing wild ponies galloping along the beach in Chincoteague National Wildlife Refuge, the last remaining herd of mustangs roaming the Pryor Mountain Wild Horse Range, or a red fox running across the road during a snow storm in Newport, Rhode Island, or an alligator sunning on a grassy bank of a creek across from my home, provide me with opportunities to slow down, observe their behavior and learn more about their way of life.

Evening Stroll

Reflective Calm

Embracing Joy

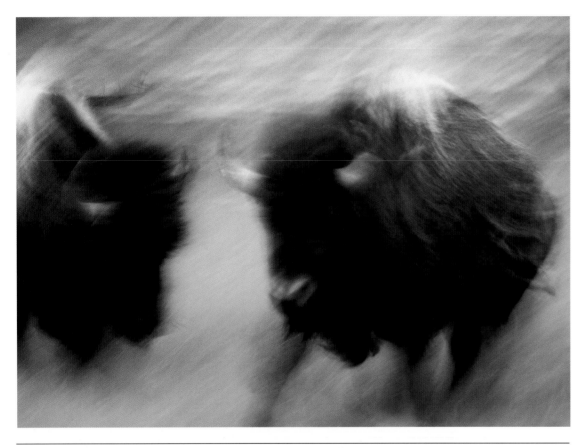

Moving Fury

In these and many other cases, I look at them as they in turn look at me. I wonder how many times I have been in the wilderness where animals have watched my every move, perhaps considered me an intruder, and went about their business without my even knowing it. Animal life is one of survival, one of finding food and water and the other protecting itself from the elements and predators. Appreciating their instincts for survival, courtship and child rearing are helpful to enjoy the moment, moments that are often fleeting.

I remember the first time I saw a bison in Yellowstone National Park. It was quite different than seeing one in a book.

> *The country before us thronged*
> *with buffalo. They were crowded*
> *so densely together that in the distance*
> *their rounded backs presented a surface*
> *of uniform blackness.*
> Francis Parkman

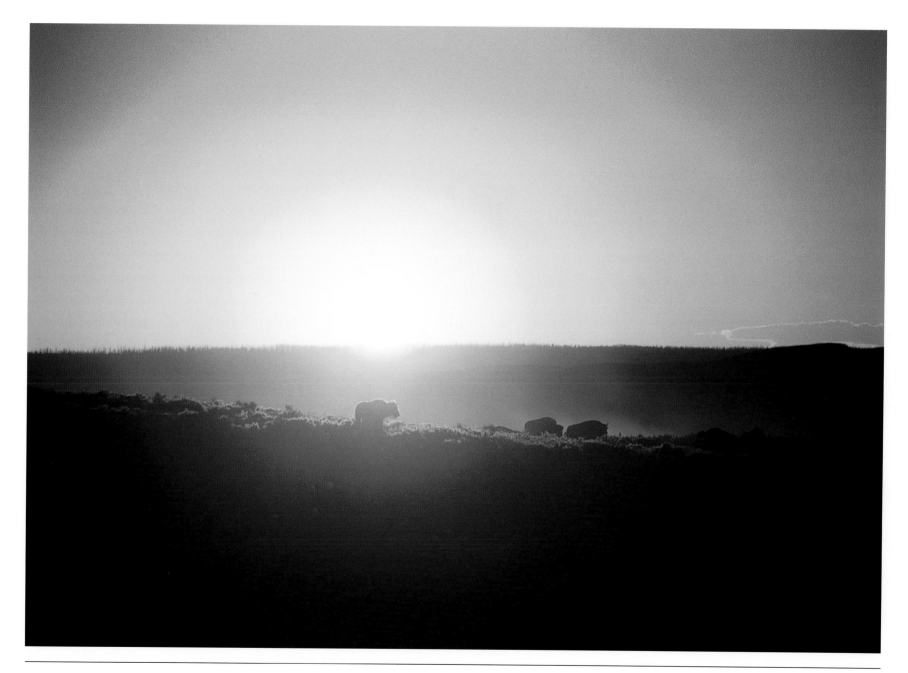

Endless Day

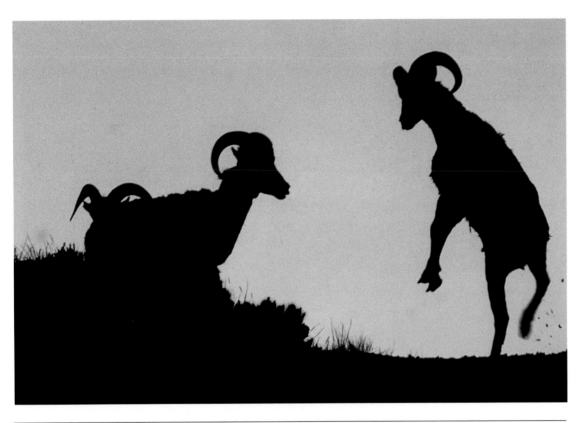

Command Performance

I was thrilled to see this ton-size mammal grazing in the field as if I were not there. Seeing them every day while spending my summers in Yellowstone spoiled me. One crisp morning while traveling along the winding Madison River, I saw out of the corner of my eye, a bison coming down the hill. I decided to slow down not knowing his intended behavior. Before I could stop, I saw hundreds herding themselves down the mountainside. I stopped just in time, as the herd, running at full speed, kicking up clouds of dust and breaking tree branches, crossed the road, swam across the river and kept on going. Wow! An authentic buffalo stampede! I remember the scene today as if it happened yesterday. The action was fast, furious and totally unexpected as I stood behind my car.

Every encounter with wildlife is unique. From the sight of bison, elk, bear, and moose in the nation's first national park, to my own backyard, I have learned to expect the unexpected. After returning from a Florida trip on a New Year's Day, I prepared to watch the football frenzy on television while it snowed heavily and the sound of the wind could be heard over the cheers on the tube. I fought to stay awake as my alma mater played scoreless, when I casually glanced outdoors. Hard to believe, just six hours earlier I was basking in the sunshine. One glance caught my attention as a thin, snow-covered red fox looked at me through the sliding glass door, appearing hungry and cold. I marveled at the beautiful scene and then dashed up to my bedroom, unpacked my camera and ran outside in stocking feet to capture this rare scene in suburban Maryland. I took several pictures of the wild reddish creature with snow on his back and tail.

We played hide-and-seek as the fox hid behind a tree and gave shy peeks. I crouched down and clicked the shutter several times. It wasn't until I got my slides back that I realized my backyard fox only had one eye, the other nothing but a blank socket. My son saw her again in the spring moving her newborn into the wooded field behind our home.

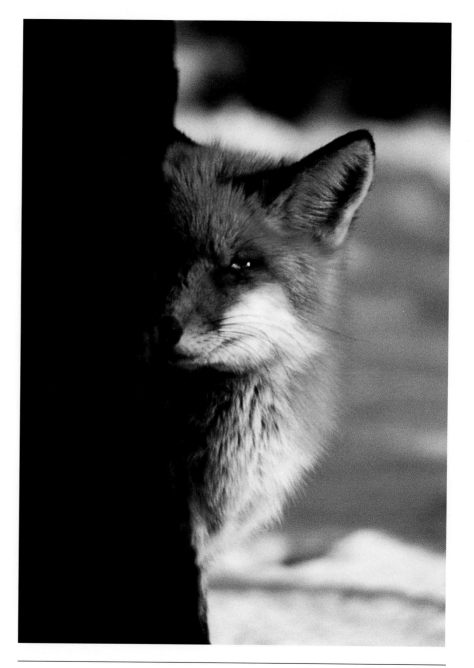

Foxy Lady

Passing Through

Just Wandering

*A moment's insight is
sometimes worth a life's experience.*
Oliver Wendell Holmes

Priceless

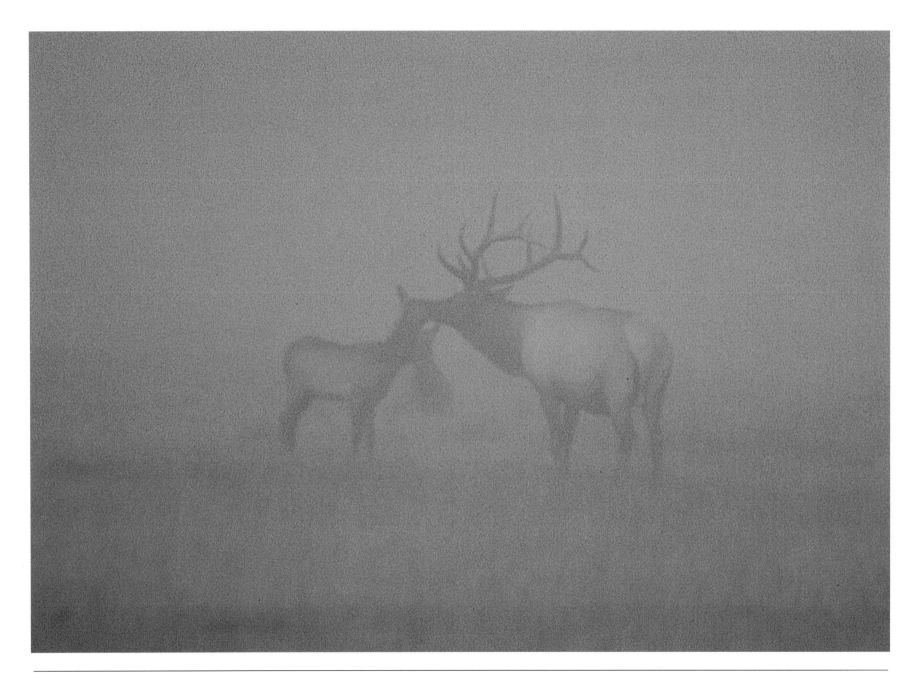

Nurturing

As I sailed the high seas off the coast of Maui during whale breeding season, I expected to see whales. I was not disappointed. I saw the fins, spouts and breaches in the distance. As we cruised a little closer to the pod, water glistened like diamonds as the whales swam in the area. Then an awesome drama unfolded before me. A female whale swam under the catamaran several times. Trying to hide from two agressive males, she then floated along in the shadow of our vessel. The experience was extra special because I was viewing it through ninety feet of crystal clear water. All of us, including the captain and his crew, later said our hearts were racing as we watched. My motto: Expect the unexpected when looking for wildlife opportunities.

Best Friends

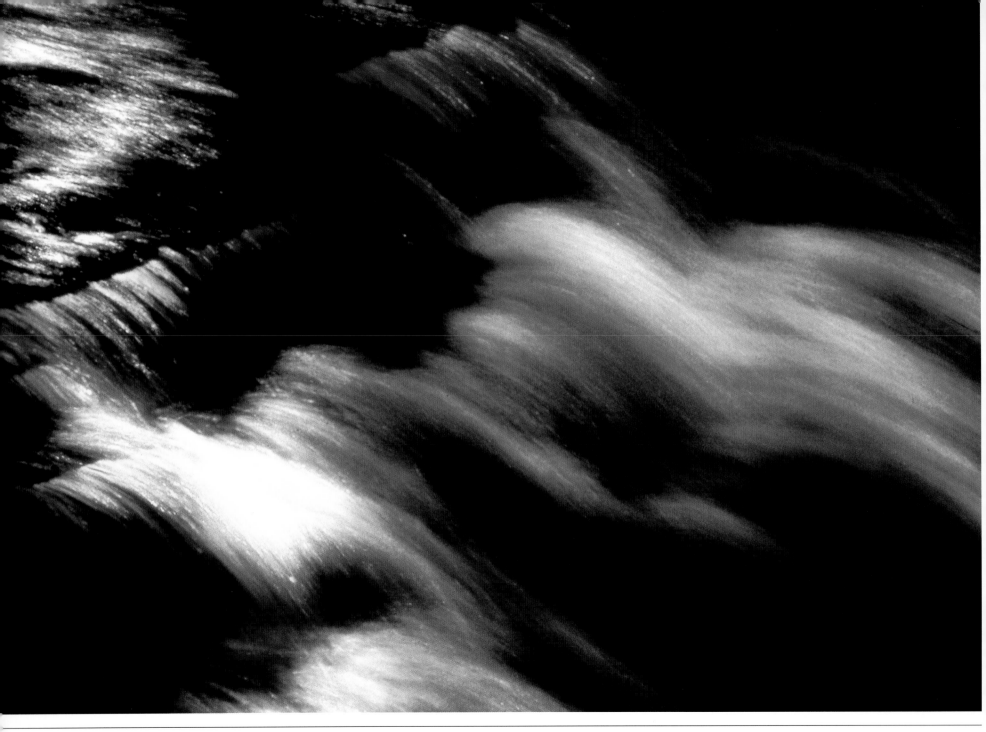

Melodious Journey

Enchanting Water

Nature's music is never over;
her silences are pauses, not conclusions.
Mary Webb

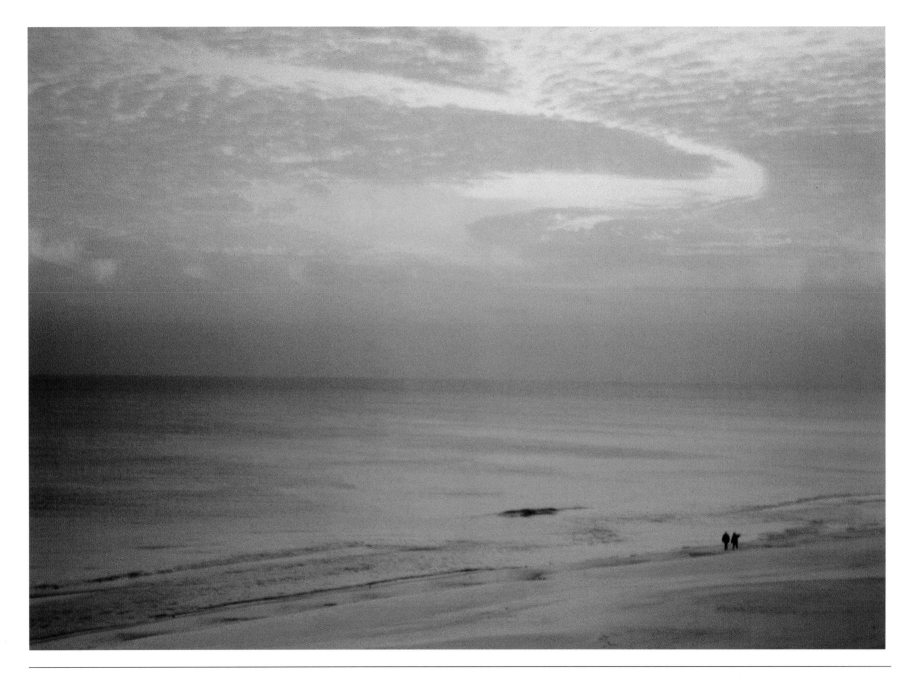

Evening Embrace

Whether I am listening to the endless music of a babbling brook, walking through a rain forest while tasting droplets of the morning dew, feeling the coolness of a glacier as an iceberg floats by, or smelling the salty air while watching sea birds dance among the ocean waves, the experience of these special moments is very rewarding.

Observe always that everything is the result of change, and get used to thinking that there is nothing Nature loves so much as to change existing forms and to make new ones like them.
Marcus Aurelius

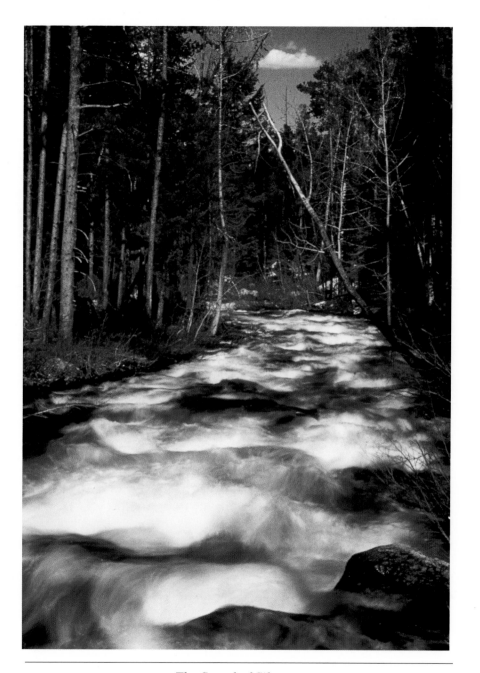

The Sound of Silence

Floating By

Water assumes many forms and does many things, as witnessed from a ferryboat up Alaska's "Inside Passage." In liquid form, it is part of all living things. I saw ponds, rivers, lakes, bays and the ocean, habitats for flora and the magnificent rain forest. I was thrilled when I saw a killer whale surface, many humpback whales breach, bald eagles flying effortlessly overhead and black bears roaming the shoreline for their daily salmon feast.

I saw massive glaciers. These ice blankets were evident by their mass of incredible hues of diamond blue. The roaring thunder of glacier calving, ice breaking off from its original form and plunging into the sea below, creates its own symphony while splashing diamonds of ice, higher than the glacier itself. Rivers of ice, using rocks as ball bearings, sculpted the earth and are often referred to as earth's original bulldozers.

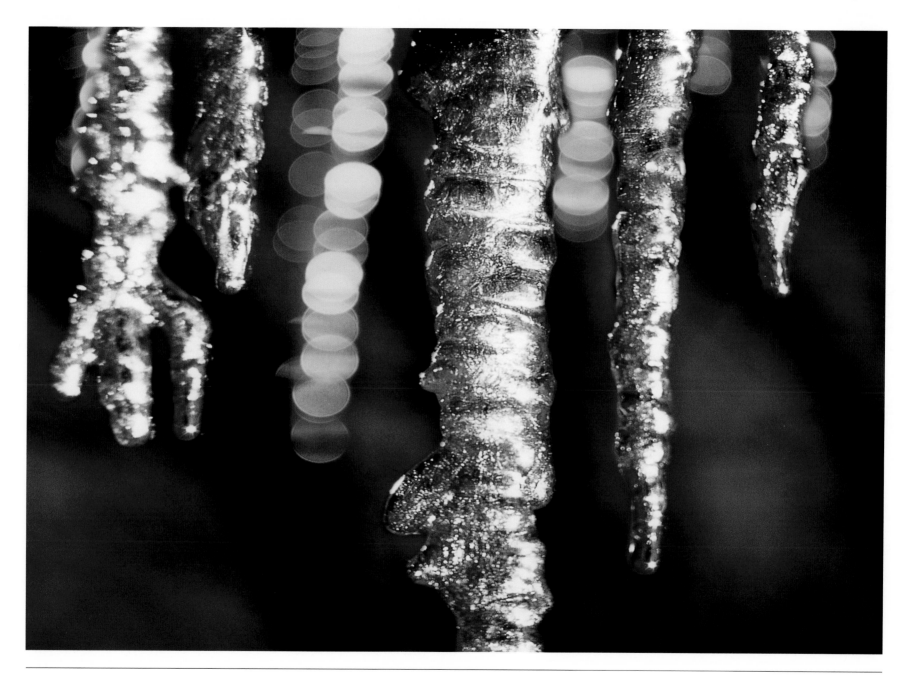

Music, One Drop at a Time

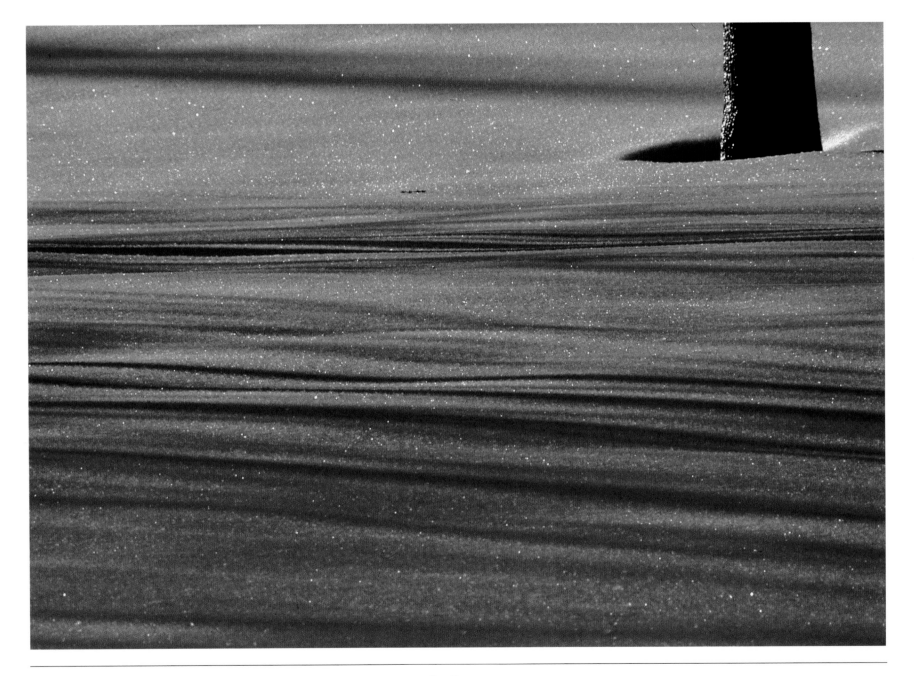

Radiance

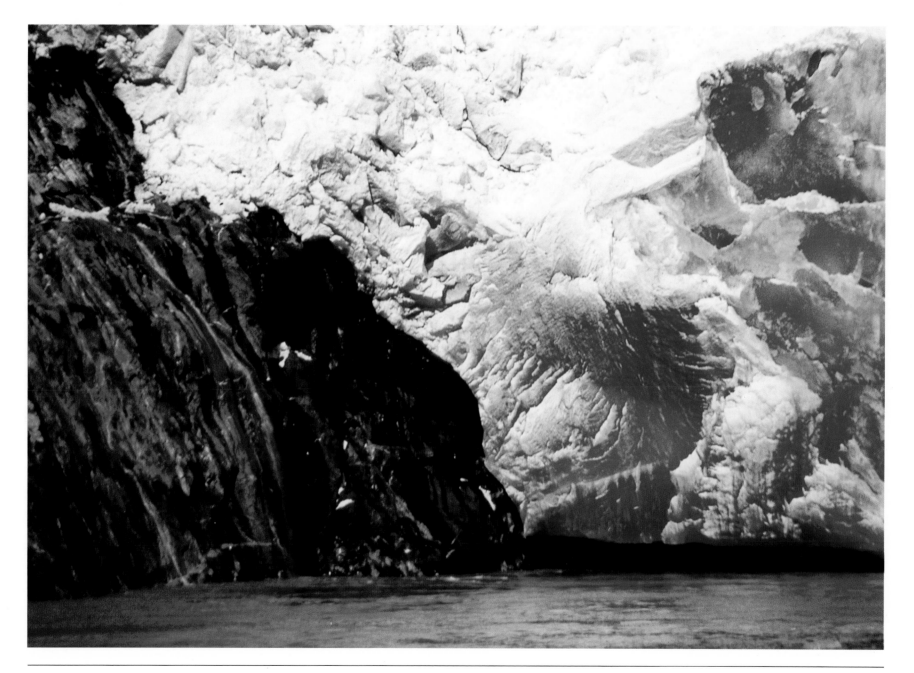

The Face of Glacial Peace

Droplets Aglow

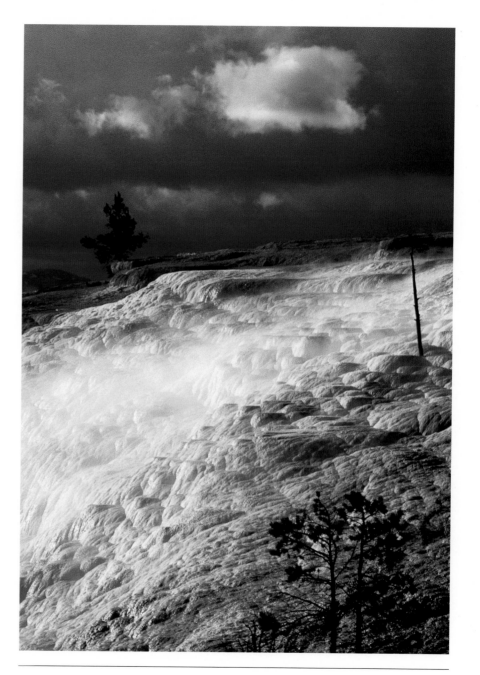

Cooling Falls

Water in vapor form, although invisible, makes weather possible. Vapor condenses into clouds, mist and various forms of precipitation and I have marveled at its beauty in the form of rain, sleet and snow. As the morning sunrise heats the cool nighttime towering trees, the mist in the rain forest on the Inside Passage rises, as "white smoke" similar to that emitted from a forest fire. Even more unbelievable, during the ten days I spent in the rain forest of Alaska, were beautiful clouds, sunshine and rainless days.

Aside from its beauty in waterfalls, lakes, streams and high seas, water is, indeed, the essential ingredient of life. It functions as a willing worker shaping the land. As the earth is rinsed clean by a passing rain, it fuels the growth of crops for our consumption and survival. As water plunges through man-made dams, electricity is generated to power our everyday needs.

Final Voyage

I have been fascinated by moving water, as I watched ships navigate our great rivers, anticipated the timing of the next salmon jump on their journey to their spawning grounds, and watched herons raise a wing to shade the water to find their next catch

Running water is one of the universal parables, appealing to something primitive and ineradicable in human nature. Day and night it preaches sermons without words. It is every man's friend . . . they cannot cross moving water without feeling its charm.
Bradford Torrey

Ripple Delight

There is a mystical creek that dries up in the fall and in the spring comes to life with the fresh Rocky Mountain snowmelt. Medano Creek, in Colorado's Great Sand Dunes National Monument is an intermittent stream that does not flow like any other. A foot deep at the most, it flows for ten miles and vanishes below ground in the valley. The mystery is the uncertainty of not knowing what it's going to do, as if it cannot make up its mind. Similar to a quick-change artist, the brownish flowing water, mixed with swirling sand, pushes the sand into temporary dams holding back more water until the water pressure breaks over its top in a wave, creating momentary surges like breaking surf. I stood in Medano Creek observing its tempo and fascinating flow.

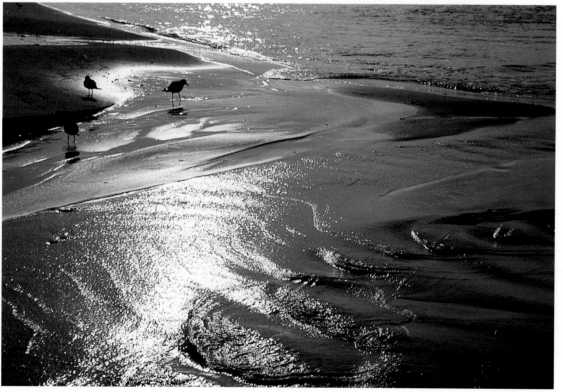

Dancing Waters

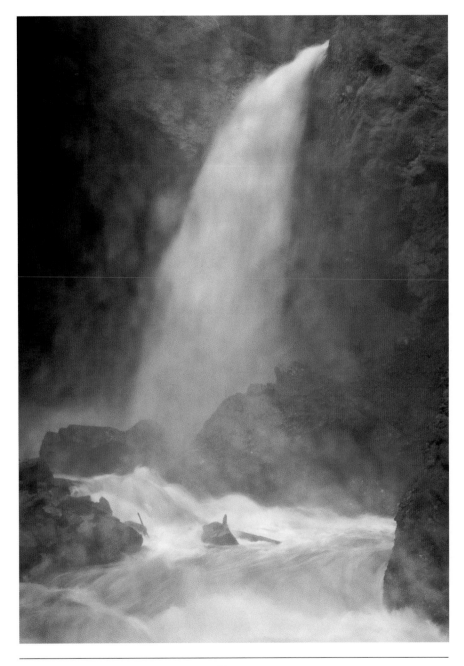

Power

When I think of the magical and calming effect of moving water, I visualize those endless flows dropping off rock banks, with an assortment of musical sound tracks provided by Mother Nature. Waterfalls are sources of crashing power and a sense of wonder.

> *They left their home of the summer's ease*
> *beneath the lowlands sheltering trees,*
> *to seek by means unknown to all,*
> *the promise of the waterfall.*
> John Greenleaf Whittier

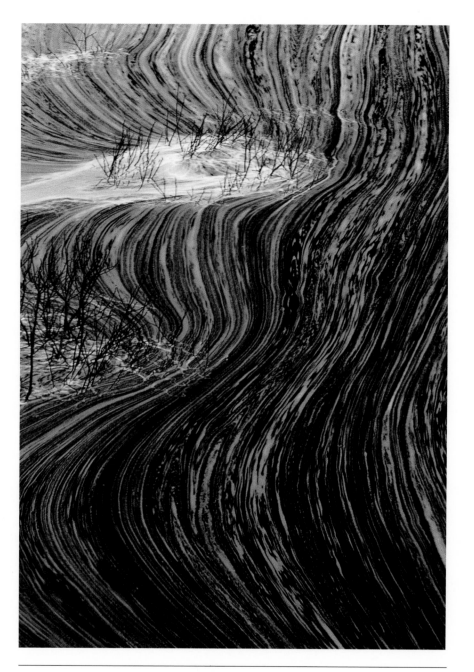

Spring Thaw

I ask myself about the attraction of waterfalls. Is it the calming sound of rushing water? Is it the crashing power of the river dancing as it goes over a cliff? Or is it a sense of wonder that nature forms such beautiful pieces of artwork from rocks and water? Whatever, the magic providing that power, serenity and peacefulness, their sights and sounds are enchanting.

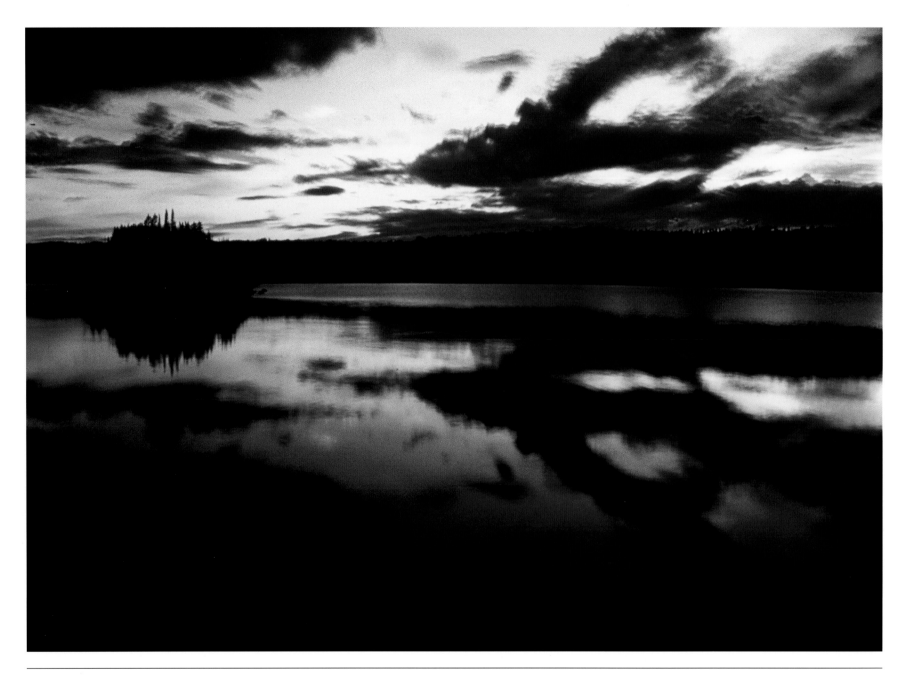

Reflective Peace

Several years ago, while backpacking down the north rim of the Grand Canyon, the lower I went the hotter it became. Thirsty, grimy and sweaty, I found an occasional face-splashing in the ice-cold creek paralleling the trail very refreshing. That first night it took awhile for me to endure the cold of the creek to take a bath, but the experience was invigorating. At midday on the third day of hiking, the hiking group heard soothing water music and then saw a cascading, yet gentle, falls with its make-believe welcome sign. Within minutes, the group was playing as if in a backyard kiddy pool. We yelled and screamed with delight, as we got drenched under nature's showerhead. Rejuvenation lifted our spirits for the remainder of our journey to the Colorado River.

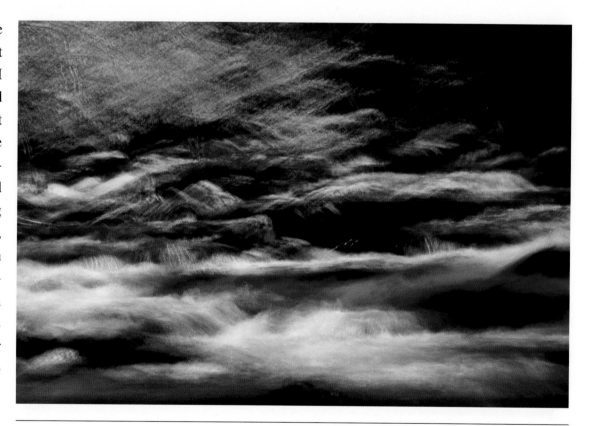

Harmony

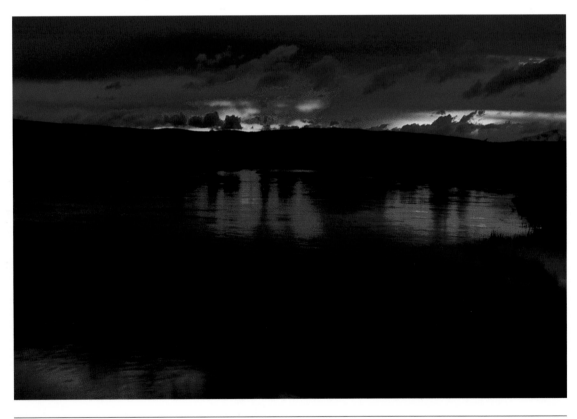

Final Curtain

On a much different trip, I saw the spectacular and powerful Lower Falls of Yellowstone, in America's first national park. An estimated 60,000 gallons of water per second pass over these falls in the spring runoff, tumbling down 308 feet to the Grand Canyon of the Yellowstone below.

> *I thanked God that right in the heart*
> *of all this noise and wrestless life of*
> *millions a wise Government had forever*
> *set apart that marvelous region as a national park.*
> Colgate Hoyt

The hiking trails along the rims of the canyon provide a potpourri of views with breathtaking experiences. In late season the "boys of summer" would graze in the fields and forests near the canyon. These boys, however, were mammoth seven- and eight-point elk preparing for the autumn rut.

One morning I hiked to the falls and saw that a crowd had gathered looking into the canyon with disbelief. One of the elk, apparently crossing the Yellowstone River, had been swept up by the swift current and taken in and over the falls. With the elk lying on the edge of the frigid river below, motionless and breathless, I overheard park rangers discussing a course of action—either let nature take its course or retrieve the elk and move it elsewhere. A grizzly bear had been spotted in the area the week before. The bear could become frustrated trying to descend the steep canyon walls, endangering the numerous daily visitors in the area. I often wonder if the grizzly chased the elk into the river, but I will never know! Nature did its work and the elk washed down river two weeks later.

On the Rocks

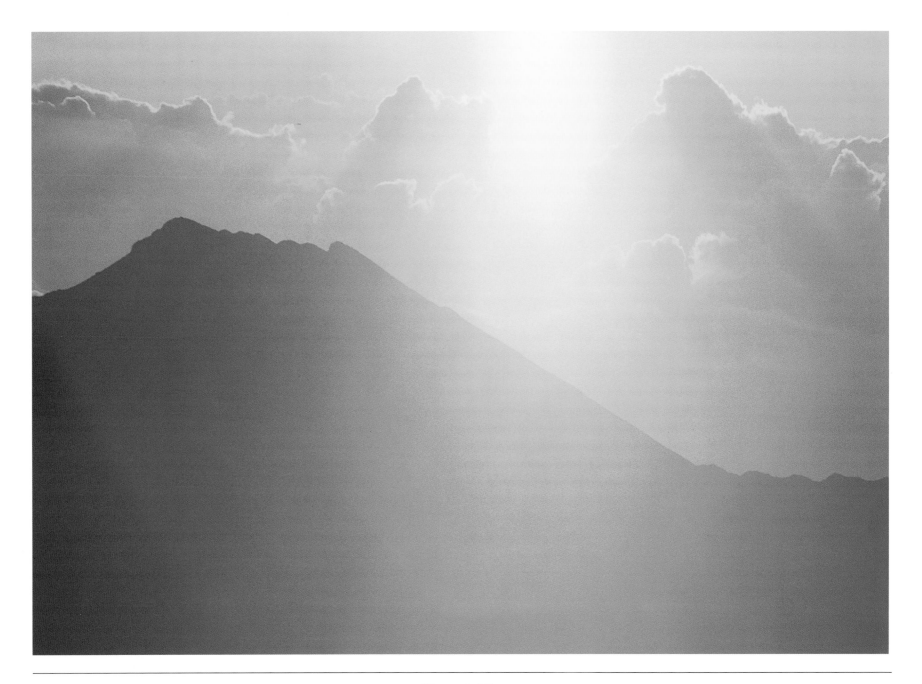

Heaven's Mist

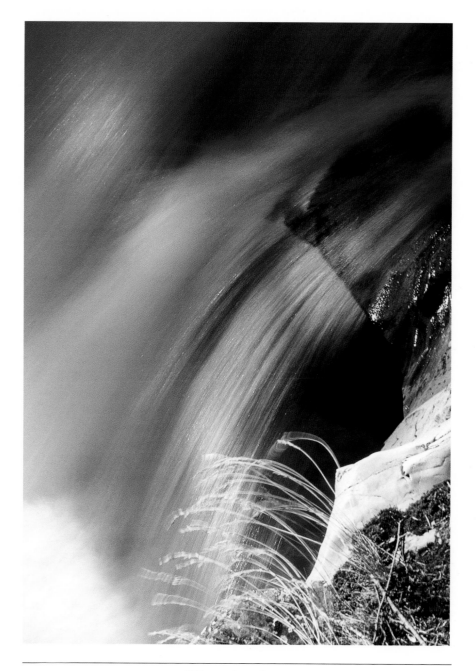

Winter Symphony

Waterfalls, those vertical spires, are a source of fascination and endless beauty with fleeting rainbows shifting as the sun and mist interact. Their mesmerizing tunes are free concerts welcoming one to look and listen to another artistic choreography.

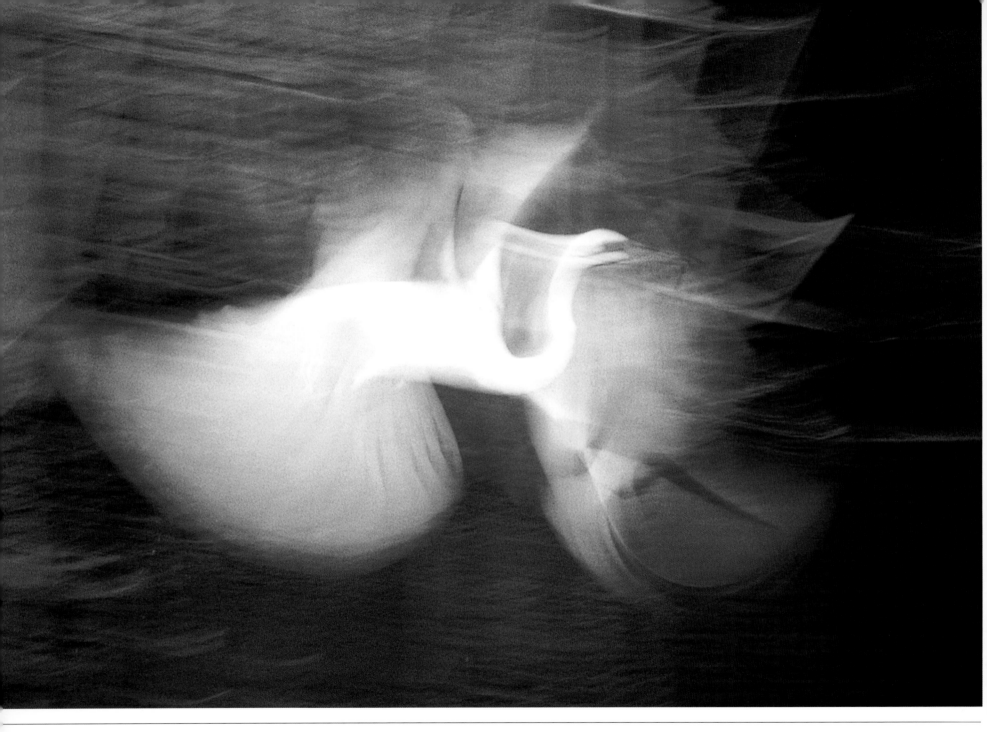

Angel Flight

Winged Odysseys

*No bird soars too high, if
he soars with his own wings.*
William Blake

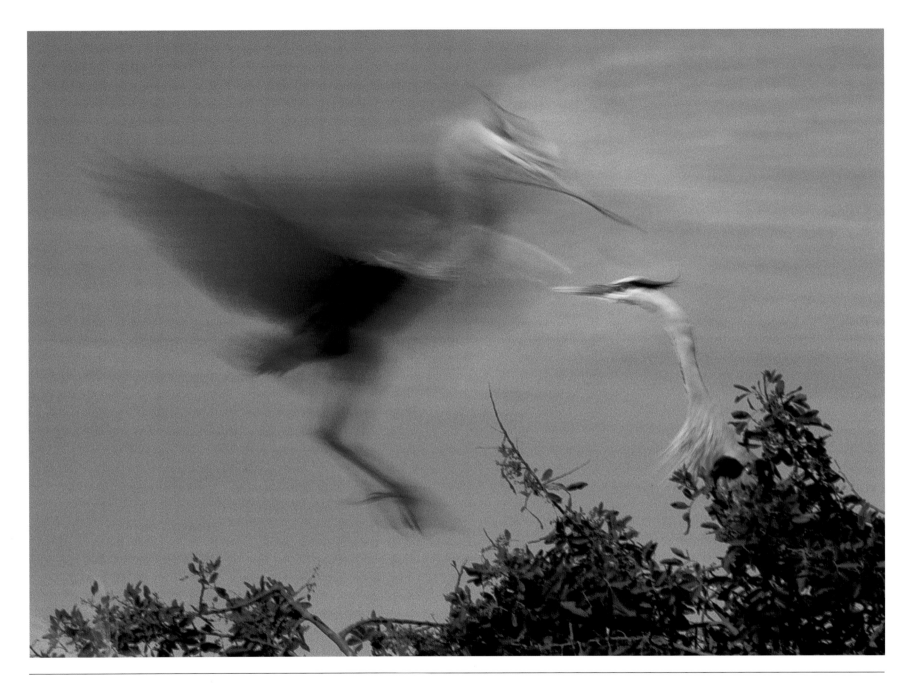

Courtship

Messenger, migrant, map reader, sentry, architect, music counselor, glider and greeter sounds a lot like reading the help wanted ads. However, these titles are but a few describing our many feathered friends. Birds signal the start of a new season in the spring. They migrate thousands of miles using the constellations along with their inbred mapping skills. They establish their territory while the architect builds his new home or repairs an old nest. Their music introduces a new day and soothes the soul, as they glide, sway and flutter about. They forage for food most of the day, sing joyful songs entertaining us, try to attract a mate, and rest during the darkness of night.

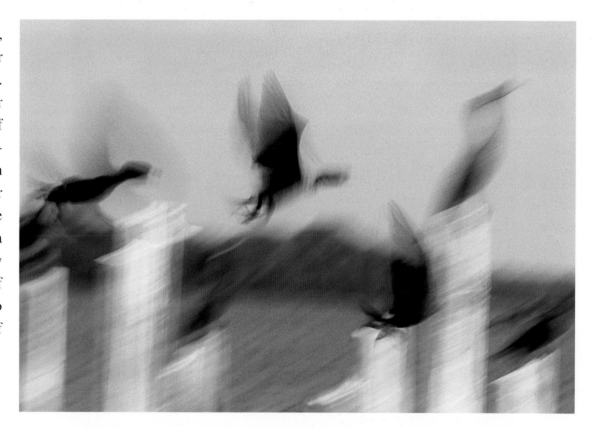

Taking Flight

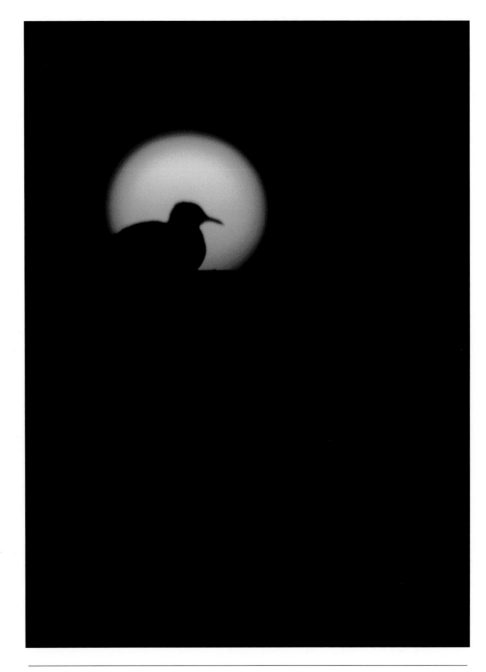

Night Shift

Our winged neighbors are the star attraction in the rhythm of the day. The greatest symphony and art gallery in the world happens as the pre-dawn light leads into day and the sun comes up to the sound and sight of birds. Birds generally please us—they eat bugs that annoy us; at dawn and dusk, they pollinate our flowering trees as they sip on the nectar of the blossoms. They eat seeds and spread them during aerial flyovers. Their cackles awaken us and their spotting on windshields may cause dismay, yet their beauty and grace entertain and please us more.

The birds I heard today . . . sang as freely as
if it had been the first morning of creation.
Henry David Thoreau

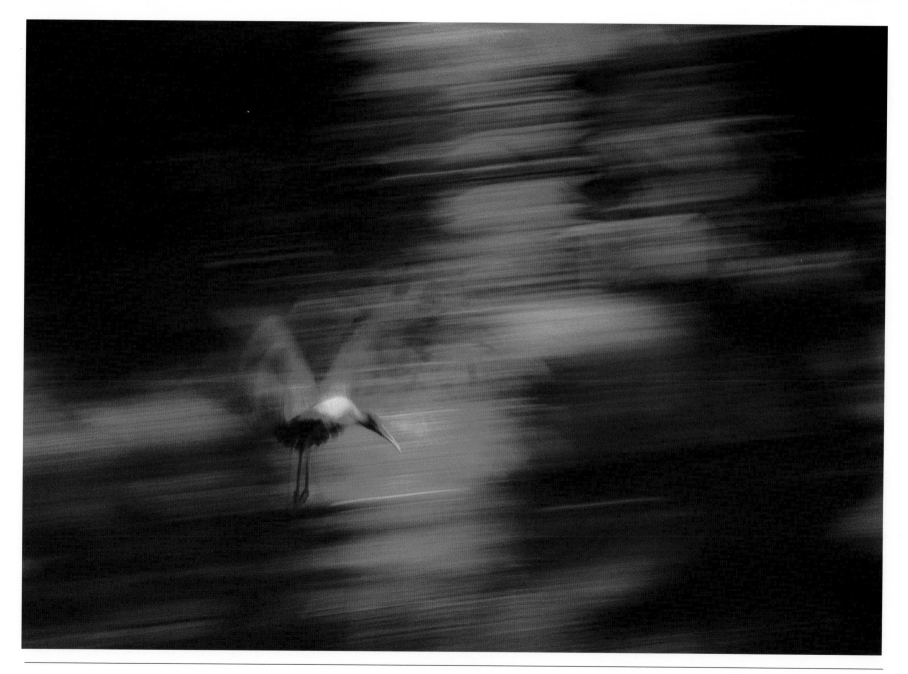

Final Approach

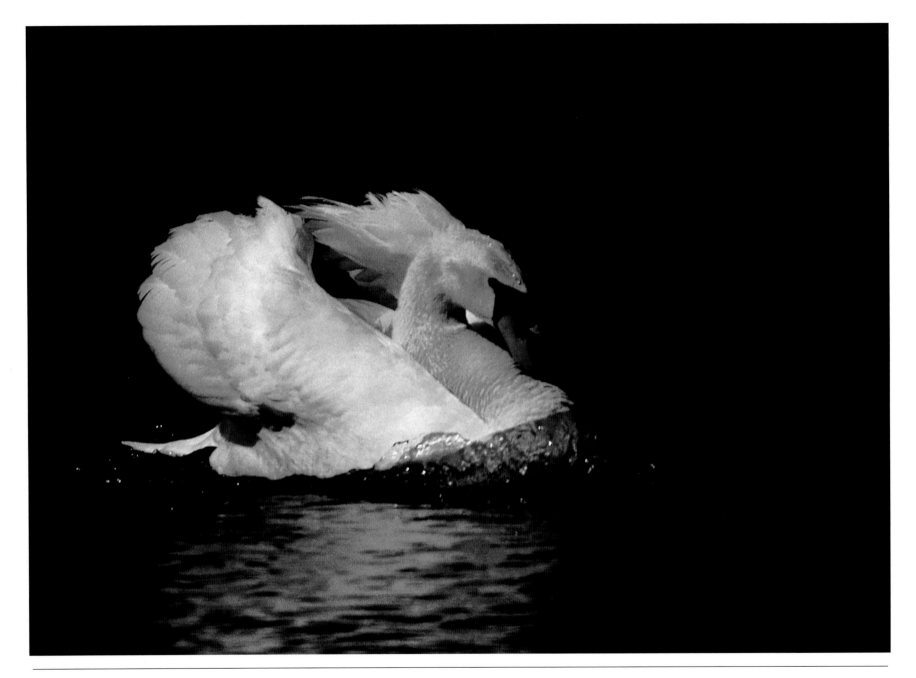

Amazing Grace

Their colors, songs and movement arouse my spirit. The world's 8,000-plus species, ranging in size from mere grams and inches to eight feet tall and weighing 300 pounds (the non-flying ostrich), are marvels to the human eye. I enjoy watching their behavior. I consider myself a bird-watcher rather than a birder who maintains an elaborate list of sightings. I appreciate birds' beauty with my eyes and ears.

While resting in my camp chair, waiting for the campfire to burn down to red-hot coals so I could cook my dinner, I felt a swift breeze pass my right ear—a breeze that startled me not knowing what it was. I felt pecks on the bill of my baseball cap, once and then several times more. Startled, I got up waving about my arms about, my cap in hand, defending myself against the unexpected "attack." There were sand dunes off in the distance, near Alamosa, Colorado. I wondered what was happening in what had been a peaceful setting.

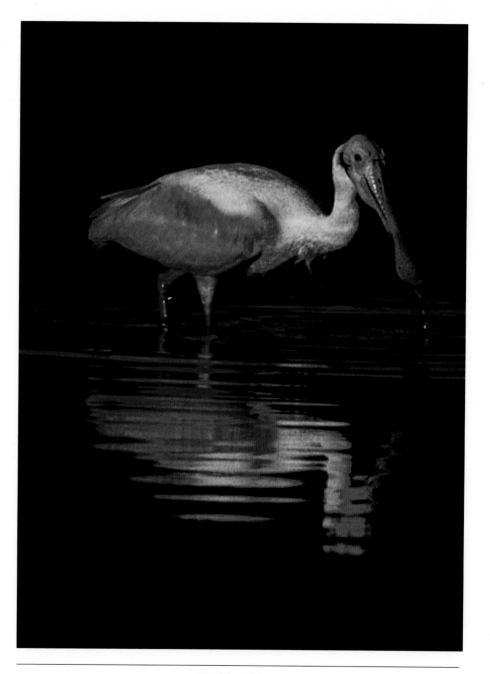

Fashion Show

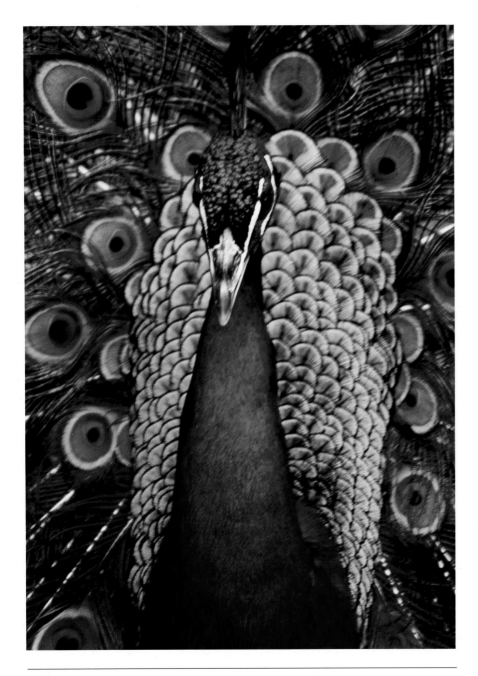

Perfection

A nature lover is a person who,
when treed by a bear, enjoys the view.
Anonymous

I saw my attacker, which fluttered its wings up to eighty times per second. A mere hummingbird, weighing in at an ounce or two, the length of a toothpick, had raised my adrenaline to new heights. What I didn't realize then, but soon discovered, was a lesson in the power of color—the color red. The bill of my new cap was a bright scarlet. It took a couple of "attacks" before I realized that I had invited and . . . yes . . . asked for this invasion. Sitting around the fire, I reflected on the drama bringing a smile to my face and a tale to tell.

Reflective Mood

When I lived in suburban Washington, I enjoyed watching the birds coming and going in backyard woods and feeding on feeders. When I moved to Southwest Florida, one of the first things I noticed was the lack of birds flying about. I am sure their environment had been disturbed with all the new construction going on. I put out bird feeders, but was surprised when I had no takers. I installed two birdbaths and filled them with clean clear water, watching the ripples in the water dance from the wind, but no bathers. I wondered what would happen if I tacked an orange segment on the tree next to the birdhouse. I did and again nothing happened. However, on a cool morning I looked out the window and saw not only the rising sun, but also a red-bellied woodpecker feasting on the orange.

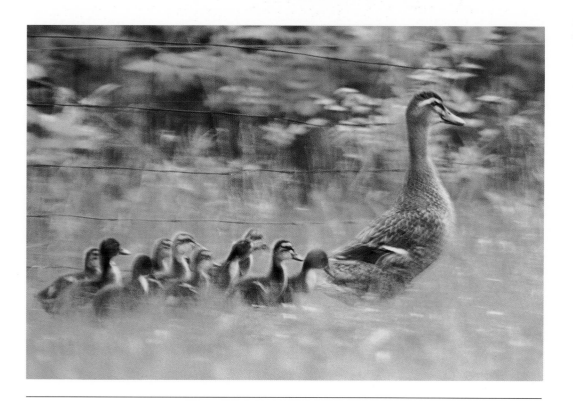

Ducklings on Parade

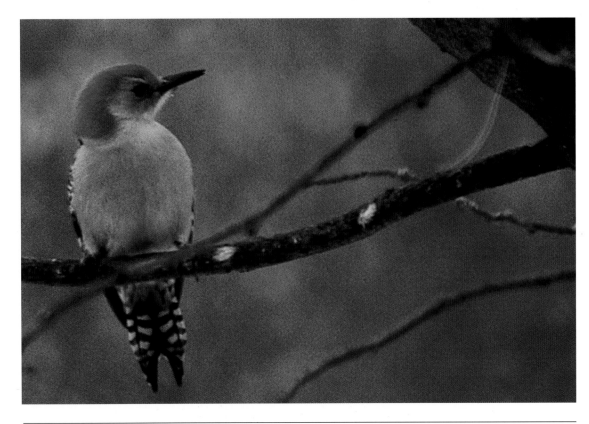

My Best Side

Wow! A bird had taken my bait. Late in the afternoon he appeared again. This went on for days as if the woodpecker had a schedule to keep. On the fourth day, I heard what I interpreted to be cries of distress. To my amazement the core of the orange was gone! I replaced the old with a new bright orange cut in half, and heard a song of thanks as the woodpecker went about his morning juicing. Appearing for the afternoon appointment, were not one but two birds feeding on the citrus fruit. I was pleased that the feeders, birdbaths and orange teasers brought some new winged friends to my back yard.

One afternoon, several weeks later, I was sitting on my screened porch waiting for what had become the afternoon ritual. Just like a curtain going up on the next act of a play, the male came by first for his daily treat. Then the female came in for a landing on the tree, beginning her typical scaling and lowering a few inches at a time until she reached the nectar of the day. Then a musical chorus broke out that I hadn't heard before. The birds were announcing the arrival of their expanded family. Not one, but two small woodpeckers flew to the tree and hugged the pine bark with their tiny feet. The mother bird plucked pulp out of an orange segment, flew up to her clinging chicks and put the pulp into their squealing mouths-like spoon—feeding our young. The repetition of this seemingly simple but necessary task went on as the male bird, a proud dad, kept watch over the children from the sky.

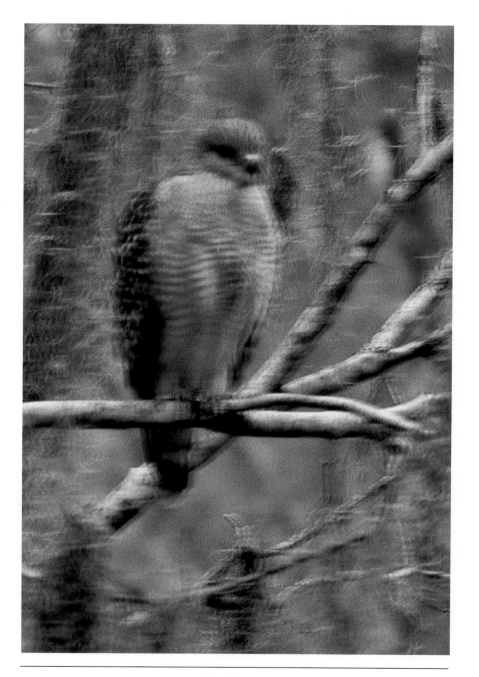

The Shivers

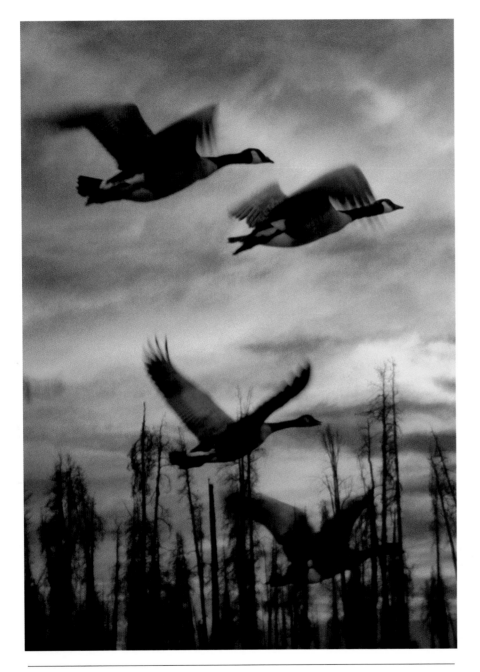

Wisdom Flight

Birds are, indeed, fascinating. Whether it is seeing Canada geese waddling and honking among the reeds in a swamp pool, or juncos and canaries feeding nonstop on a feeder, watching an eagle or osprey catch a fish with his talons, or watching robins or herons carrying building supplies to their nests, it is all a part of everyday life, much of which goes unnoticed.

We can go to the art galleries and museums to see beautiful artwork, but the transitory masterpieces of pelicans, gulls, terns and egrets displayed on our beaches, whether feeding or taking flight is art in real time. The focus and attraction of birds grows while viewing their true grace and beauty as they emerge in flight. Taking off and landing on runways of land or water, gliding effortlessly or soaring gracefully, displaying their aerial mastery, and at the same time, they show off their palette of plumage, this is visual and musical poetry at its finest.

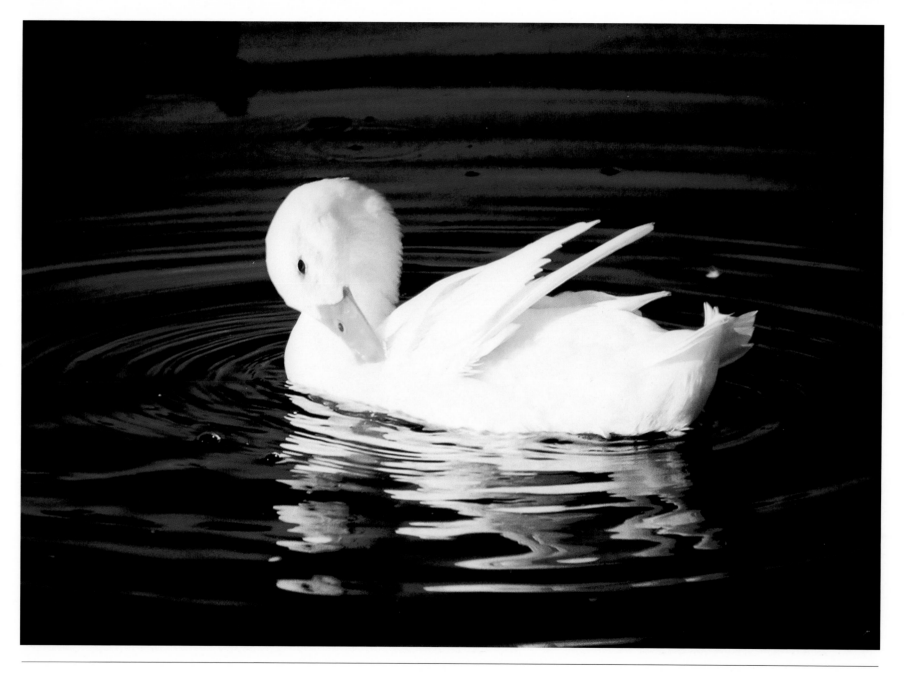

Preening Time

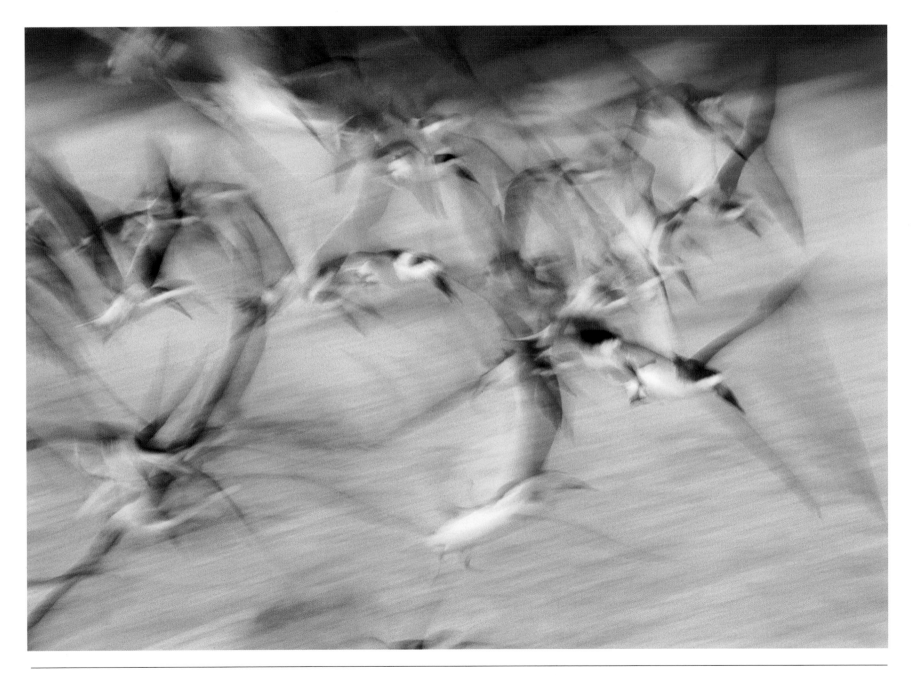

Flying Ballet

Freedom Soars

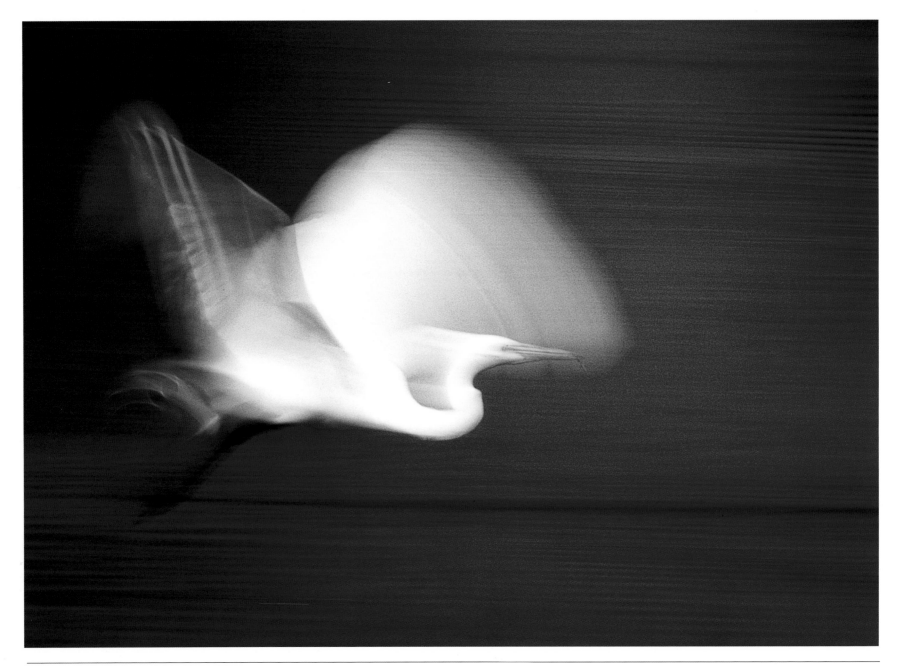

Elegance in Motion

Inspiration

Brunch

The world acquired a new interest when
birds appeared, for the presence of birds
at any time is magical in effect.
They are magicians that transform every scene;
make of every desert a garden of delights.
Charles C. Abbott

Birds are messengers, architects and migrants. They are a feast of beauty and song as they act out their everyday life for us to see while we listen to their melodious songs.

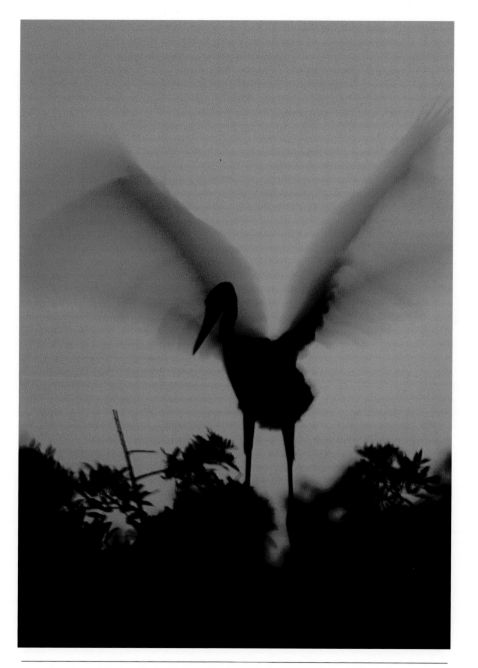

Bird's-eye View

135

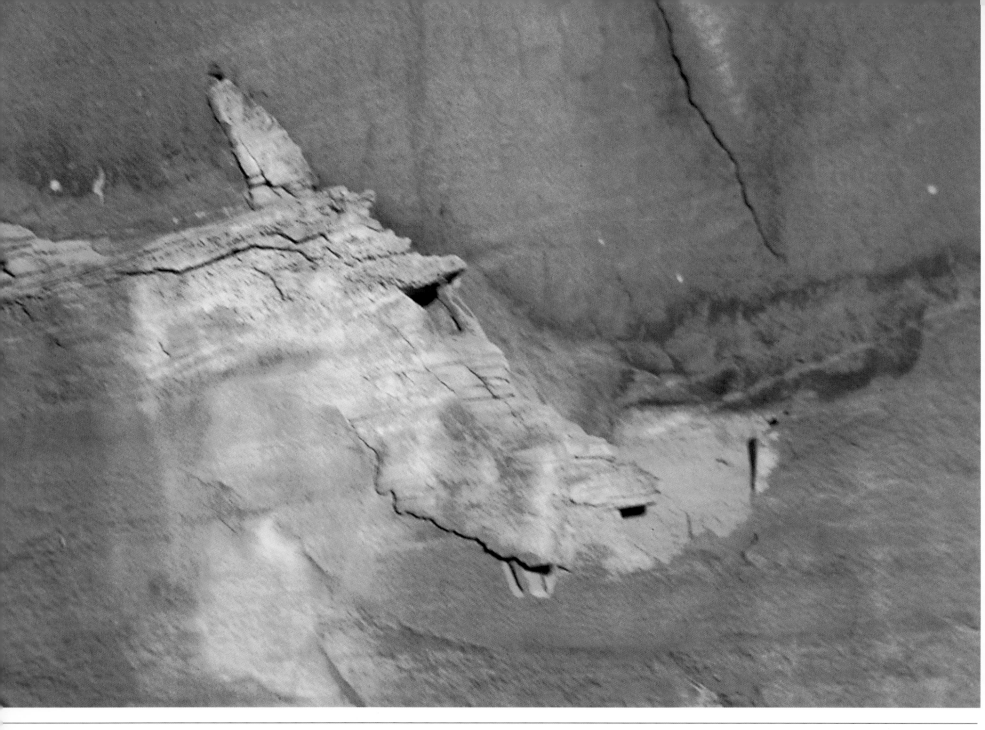

Bridle Rock

Rocks that Speak

*The art of seeing nature is a thing almost as much
to be acquired as the art of reading the hieroglyphics.*
John Constable

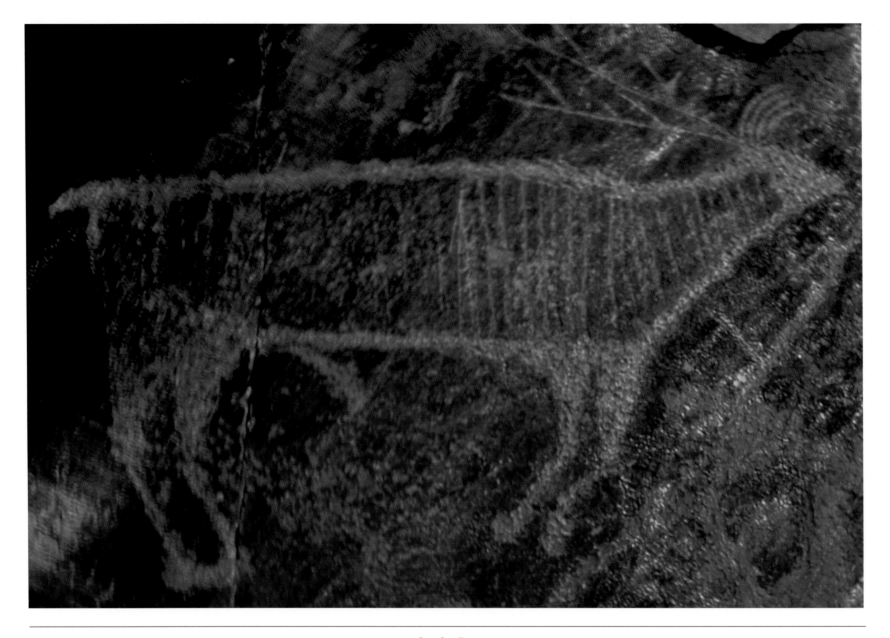

On the Run

It was a sweltering clear, blue-sky day as I rested on a rough and very warm log at the bottom of the hillside adorned, with carvings from another time. With one eye trained on a huge, bald eagle nest waiting for its host to return and the other eye gazing at an incised carving on a high tannish-brown rock wall depicting, from a Native-American perspective, a likeness of America's symbol.

Even the rocks, which seem to be
dumb and dead as they swelter
in the sun along the silent shore,
thrill with memories of stirring
events connected with the lives of my people.
Chief Seattle

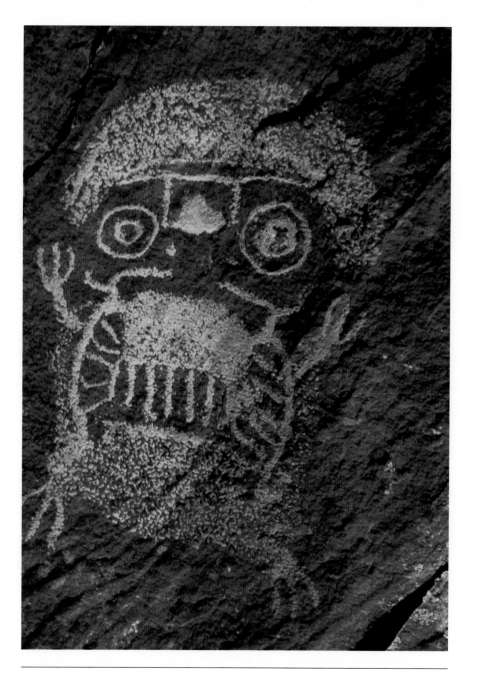

Spirit Song

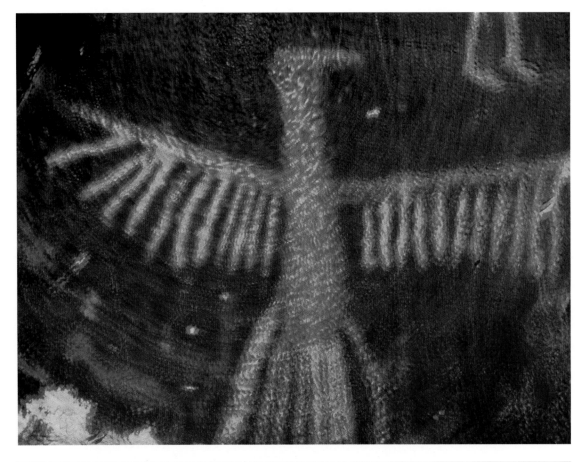

Symbolic Etching

Dripping with sweat I sat on that decaying log in Legend Rock Petroglyph Park outside Thermopolis, Wyoming, on a day hot enough to blister paint and I pondered the significance of this special breathtaking moment. What was the message on the rock cliff before my eyes? Who made the inscription? How long ago or how recently? Why was it made? What does it signify? How and what instruments were used to make it? These, and many more questions raced through my mind as I drank from my sun-heated water bottle and rested from my short climb over craggy rocks to get a closer look. Just amazing! The petroglyph existed in the same area as the real eagle, or vice versa. Amazing how close I could get without actually touching them, and that they appeared intact and not vandalized like so many others.

Petroglyphs, also referred to as rock art, are pecked marks made on rock in the landscape—on cliff sides, on boulders, and other stone formations and special places. I discovered that petroglyphs cannot be read like words, but the carvings do speak to the heart, mind and soul. Interpretations are similar to images exposed on film. Just as photographer records special moments, documents history, tell stories, or expresses a personal vision, so do carvings on stone. They are both a means of communication. Just as I bring my own experience and purpose in conveying messages with my images, I suspect Native-Americans were also conveying messages in their carvings. However, people interpret photographs and carvings based on their own experience and belief, which can be very speculative and subjective. The identification of actual rock art is, in many cases, like cloud watching. No two people will see the same vision in the same cloud mass.

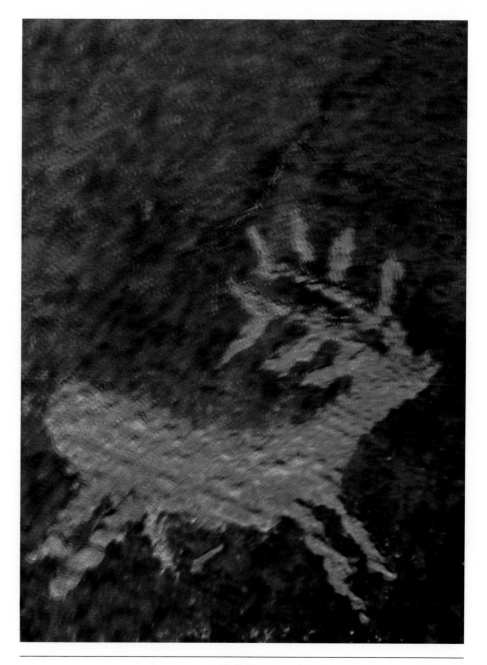

Fall Rut

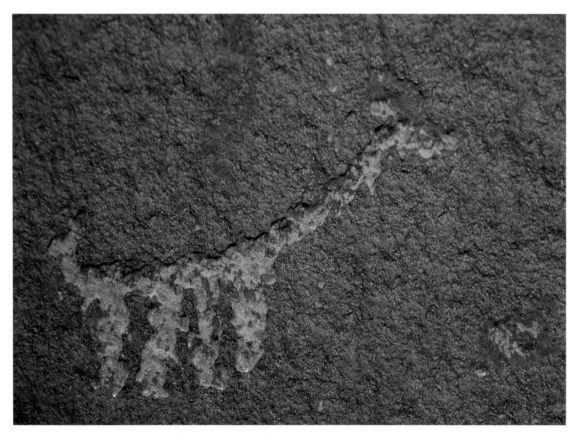

If I Could Speak

Nature photography has led me to new discoveries. With a group of nature photographers, I was introduced in the early '90s to ancient Indian writing through pictures, not words, in the Wind River area south of Dubois, Wyoming. I was fascinated with the carvings on rock cliffs.

It seems natural that rocks which have lain under the heavens so long should be gray, as it were an intermediate color between the heavens and the earth. The air is the thin paint in which they have been dipped and brushed with the wind. Water, which is more fluid and like the sky in its nature, is still more like it in color. Time will make the most discordant materials harmonize . . .
Henry David Thoreau

Petroglyphs generally are very visible, their color contrasting sharply with surrounding rock. The carving removes the dark varnish and exposes the lighter-colored interior of the rock. The Native-American's legacy on stone represents a variety of visions, many of the natural world. The reasons for carved images on stone has been researched and studied for years. When we give a design a name, that doesn't necessarily tell us what it meant to the petroglyph artist. He may have been recording history, marking the landscape for game hunting, spiritual life, a vision quest or he might have been telling a story. For example, if one saw a "Smokey Bear" symbol of a bear wearing a hat, with no other clues, would we know it represented forest fire prevention? That is why it is difficult to interpret with certainty what all the signs, symbols, figures, and maps represent. These visible mysteries have slowed me down to reflect on another era and to record them on film. To see them is one thing, to experience them is, indeed, thought provoking.

It is a man's heart that the life of nature's spectacle exists; to see it, one must feel it.
Jean Jacques Rousseau

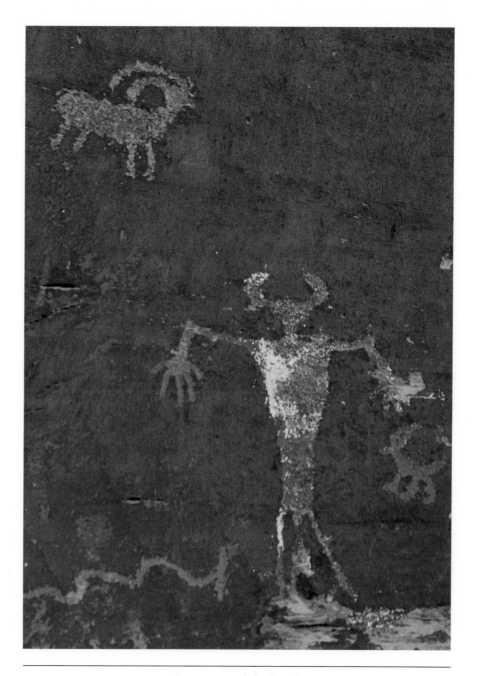

Language of the Land

Snowshoe Hare

The carvings represent a mosaic of cultures, a journey through time, and most historians agree all petroglyph sites are sacred, representing spiritual dimensions.

As a nature photographer, I have focused on finding birds and animals incised on rocks. They may give me a hint of what kind of wildlife was abundant in the area, defining tribal hunting ground, recording a trophy catch, or perhaps a form of prayer. I have concluded, however, that determining what a figure represents is one thing, but knowing what it means is another. These images serve as a gateway to visualization and contemplation. The challenge is to assign some general meaning to the figures. How "easy" it is to record subjects on film with a split second snap of the shutter. Hundreds and thousands of years ago, for whatever reason, someone took the time to peck into the patina of stone, perhaps the only known way of conveying a message. Insights into this form of communication serve as my benchmark in the kind of messages I try to convey in my photography.

It is believed that birds and animals are symbols to Native-Americans. The eagle represents a spirit of connection to the divine and freedom. The buffalo represents endurance to overcome one's weakness; the turtle represents the symbol of mother earth; a ram represents a new beginning and the bear represents power and adaptability.

The biggest and most intriguing animal I have seen portrayed in rock art is a bear with a hunter at the bear's nose on a 125-foot panel, about thirty feet up the rock wall located near Canyonlands National Park. The 125-foot long panel represents the Formative Period (A.D. 1 to A.D. 1275) defined as an overlap between the Anasazi and Fremont cultures. This "billboard" is impressive and I asked myself many questions, the most basic being how they got up there to chisel and immortalize in stone this power symbol.

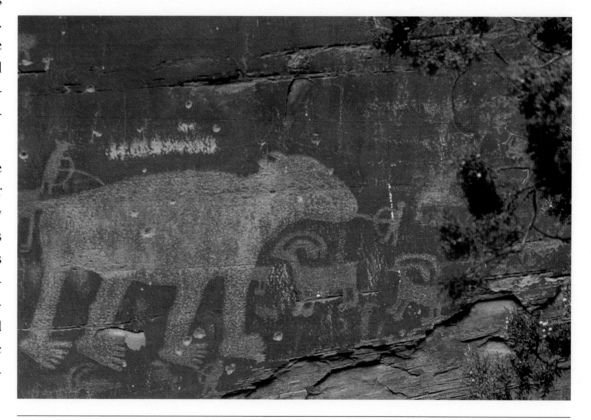

The Hunter

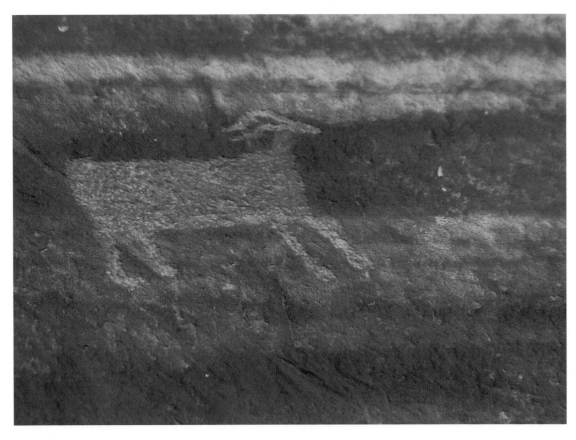

Antelope Dance

Photography is writing with light and a means of communication; the lens is no more than a tool to record messages. The shutter is the chisel and film is the medium to convey those messages. The same questions of who, what, when, how and why, are asked of photographic images today just as we try to answer the same questions regarding rock art. They are both forms of communication, one primitive and historical, and one relatively modern, yet so different in delivery and interpretation.

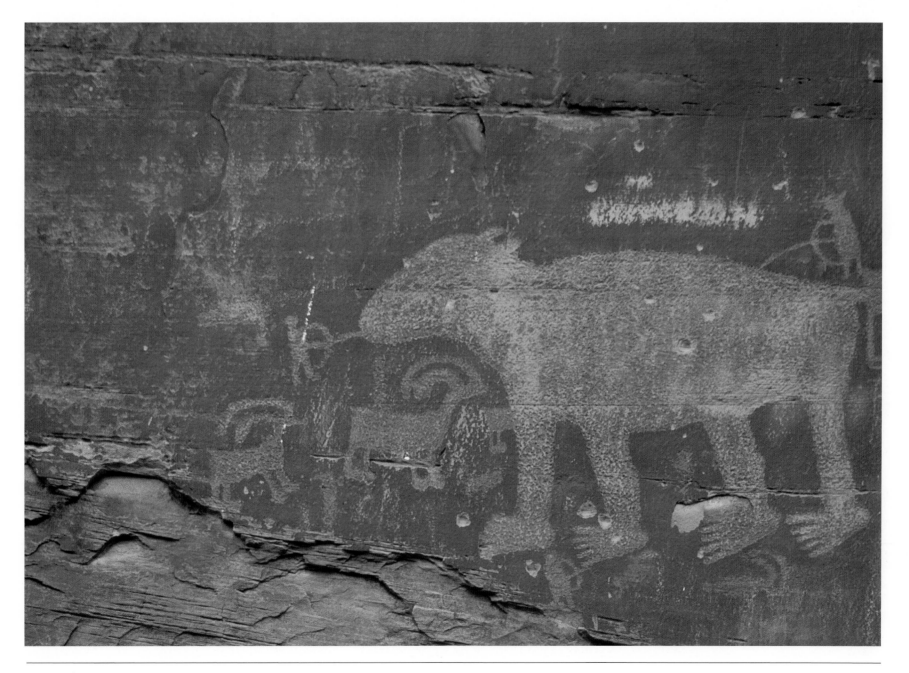

Standoff

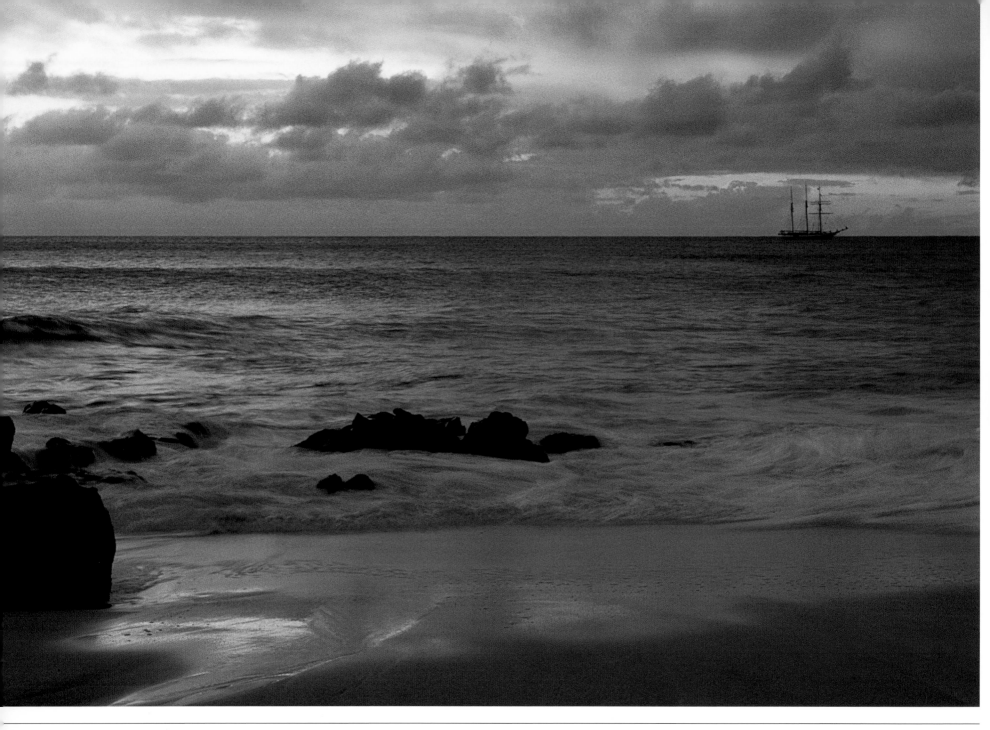

On the Horizon

In a Nutshell

Much is published, but little is printed.
The rays, which stream through the shutter,
will be no longer remembered when the shutter is wholly removed.
Henry David Thoreau

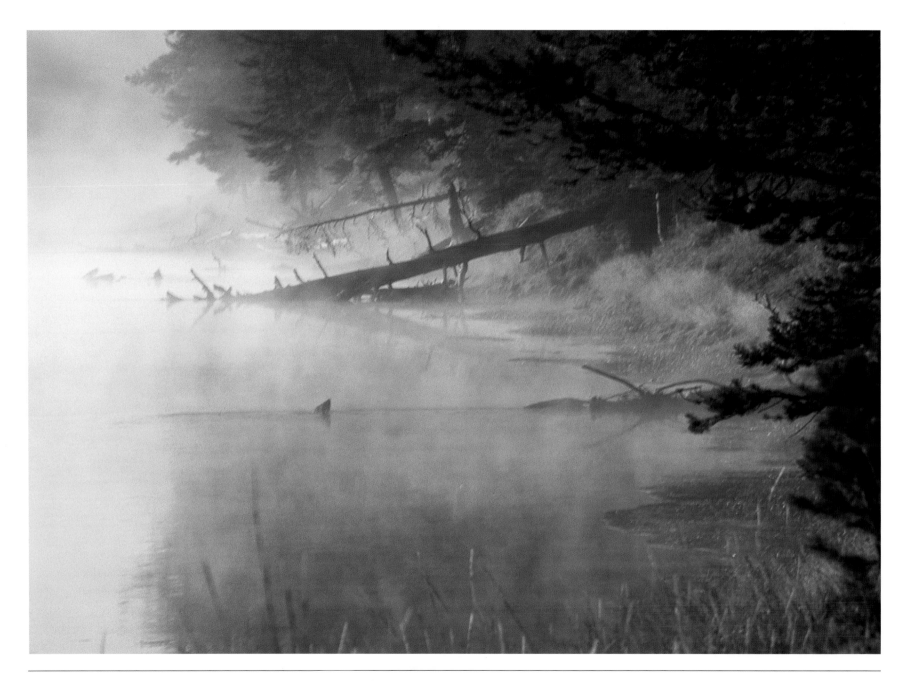

Quiet Interlude

From pine seedlings in a recovering forest to ice-caked mountain peaks, from the seemingly simple to the soaring spiritual, Mother Nature provides a palette of possibility. Nature is an arena for explorations. It is a place to get lost in as well as a place to discover oneself.

Each moment of the year has its own beauty . . .
a picture, which was never before seen
and shall never be seen again.
Ralph Waldo Emerson

Nature adds to the quality of our life and provides sustenance for the soul. The outdoor amphitheater is a choice seat for learning all that nature has to offer. It is my classroom offering a variety of experiences and challenges to a nature photographer. Nature generates life lessons, provides insights and wisdom if we are willing to listen. Perhaps the art of nature photography will assist others in fully appreciating the tangible and intangible benefits nature bestows. Nature is an open book, new chapters are constantly being written. Nature, indeed, is a teacher of wisdom.

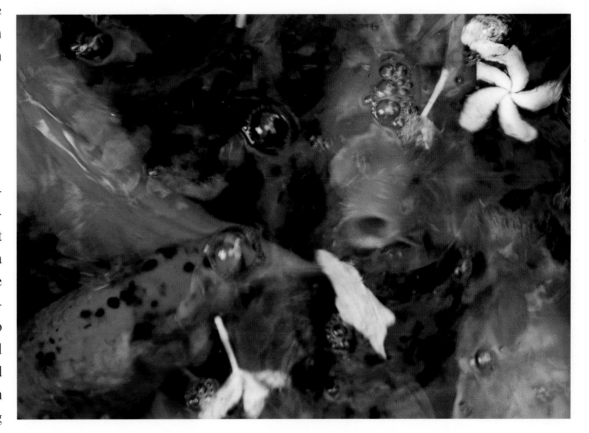

Refreshing Nature

Photographer's Notes

Cover
Crashing Surf, Maui, Hawaii

Opposite Half-title

Dedication

Contents

Introduction

The Tapestry of 'Scapes

Artistry in Bloom

Fire as the Artist

From a Seedling

Wildlife: Expect the Unexpected

Enchanting Water

Winged Odysseys

Rocks That Speak

In a Nutshell

Note: None of the images have been subjected to computer enhancement or manipulation.